TROPE

IN
KYOTO

TARO MOBERLY

TROPE PUBLISHING Co.

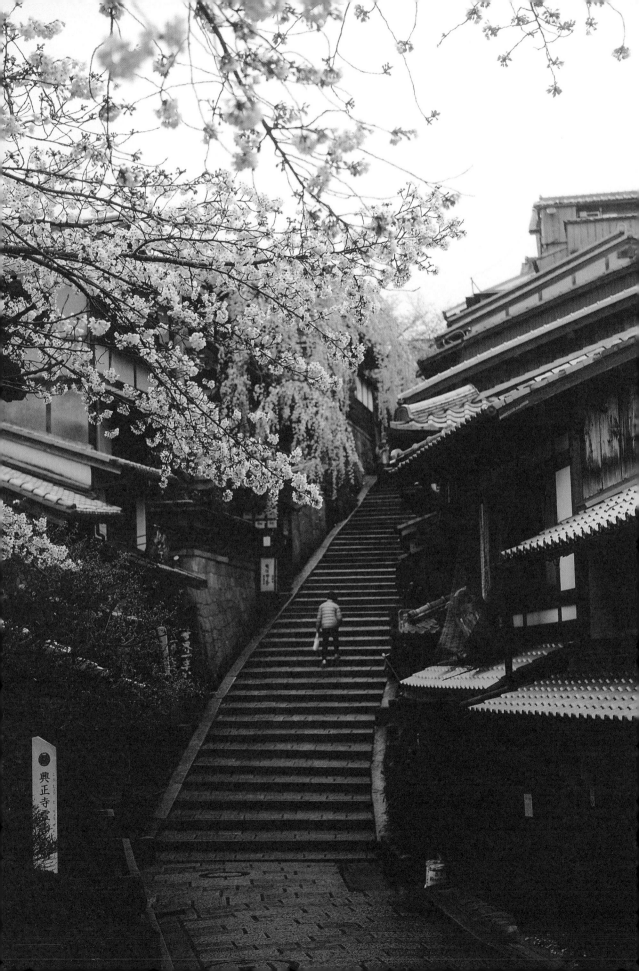

FOREWORD

———

In Kyoto is a window into that ancient city through the distinct lens of street and travel photographer Taro Moberly. A native of California, Taro moved to Kyoto in 2015 to connect more deeply with his Japanese heritage.

Though Kyoto is now his home, Taro's view is perhaps filtered through nostalgia for the Kyoto of his childhood visits to family. Even familiar places never look quite the same as an adult. And in much the same way that Kyoto weaves together reverence for tradition with forward progress, favoring neither one nor the other, Taro captures this beautiful, rewarding city with one eye towards the future, and one on the past.

The 144-page edition is divided into five chapters depicting Kyoto's past and present through its variable weather and seasons. Accompanying the 88 photographs shot over five years are 13 poems and haiku that help tell Taro's story of Kyoto.

Taro's photography imbues a stark and dramatic presentation of Kyoto. His images distill this dynamic and colorful city to its essence, perhaps influenced by his childhood memories. Look deeper at his work, however, and his curiosity, his warm affection for the people, the buildings, and the scenes around Kyoto are evident throughout. Taro's particular interpretation of Kyoto's beauty opens up new and sometimes unexpected vantage points for us.

Sam Landers
Editor

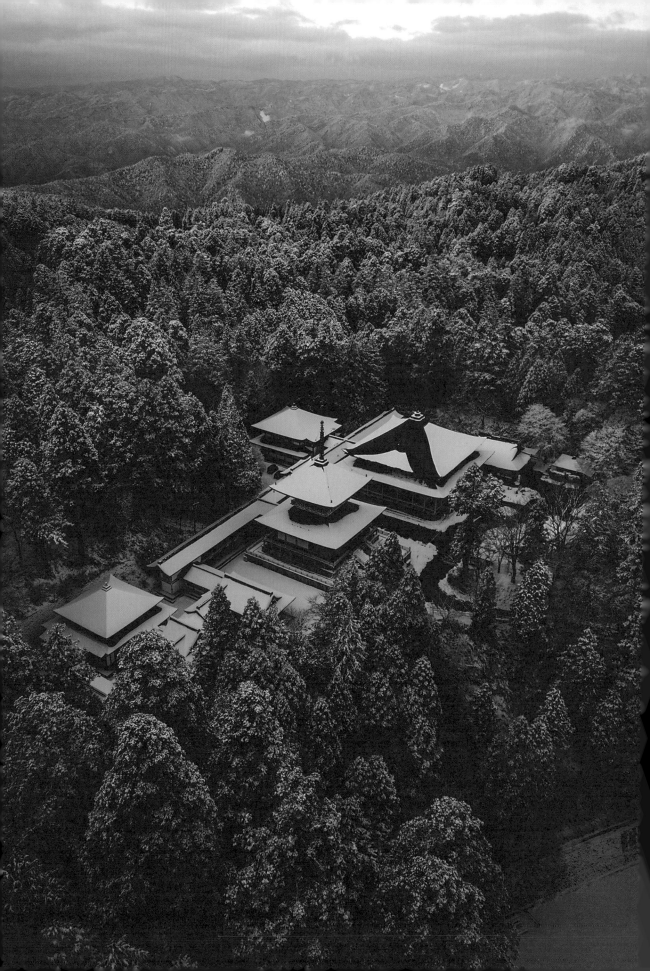

INTRODUCTION

———

Kyoto has countless stories to tell. It is a city deeply rooted in culture, holding true to traditions – some of which have lasted for centuries. It is a city that cherishes the peace and tranquility of nature, embracing the four seasons and the change that comes with them. It is a city that has grown prosperous over its history of more than a thousand years, developing into the urban center of activity it is today.

Though I grew up in the United States, I have felt a deep connection to Kyoto my entire life. My mother was born and raised in its outskirts, her ancestry rooted in the city. My parents met for the first time in the area around Kyoto Station. I have plenty of memories of visiting Kyoto as a young child to see my grandmother and grandfather: being amazed by the grandness and scale of the then-new Kyoto Station building, trying to make my way through Nijo Castle without making the floorboards squeak, watching the giant *omikoshi* make their way through the streets for the Gion Matsuri (though mostly I remember being enamored with the toy train shop on the top floor of the Daimaru department store on Shijo Street).

This connection has long given me a desire to further understand my heritage, in Kyoto and in Japan. This hunger to learn more was a factor in my move to Kyoto from my home in California in 2015. In the years since, I have discovered so much about the unique and fascinating culture of my adopted homeland. Even more keenly, this journey of being immersed in new surroundings has given me incredible insight into myself – giving me an even greater curiosity about the world around me, driving me further to explore what Kyoto has to offer. Kyoto has changed how I see the world and helped me become the person I am today.

This book you hold in your hands is a culmination of these past years, the exploration of this city that I hold so close to my heart and the stories that it has to tell. I'm glad to bring you along with me on this journey.

Taro Moberly

京にても
京なつかしや
時鳥

松尾 芭蕉

Even in Kyoto

Longing for Kyoto

Hearing the Cuckoo

Bashō

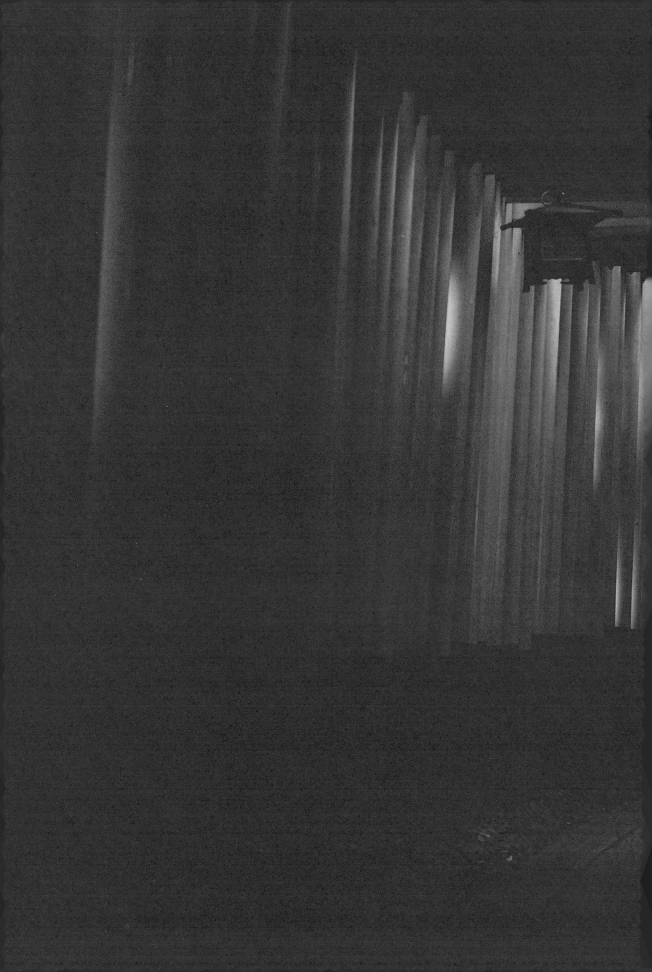

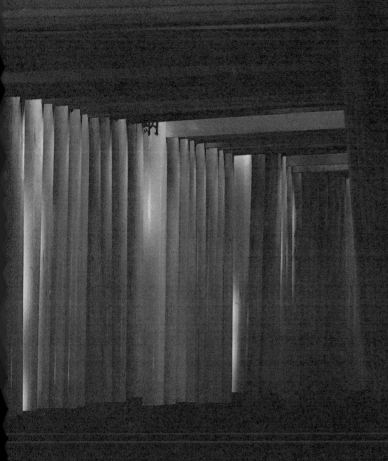

京に

IN KYOTO

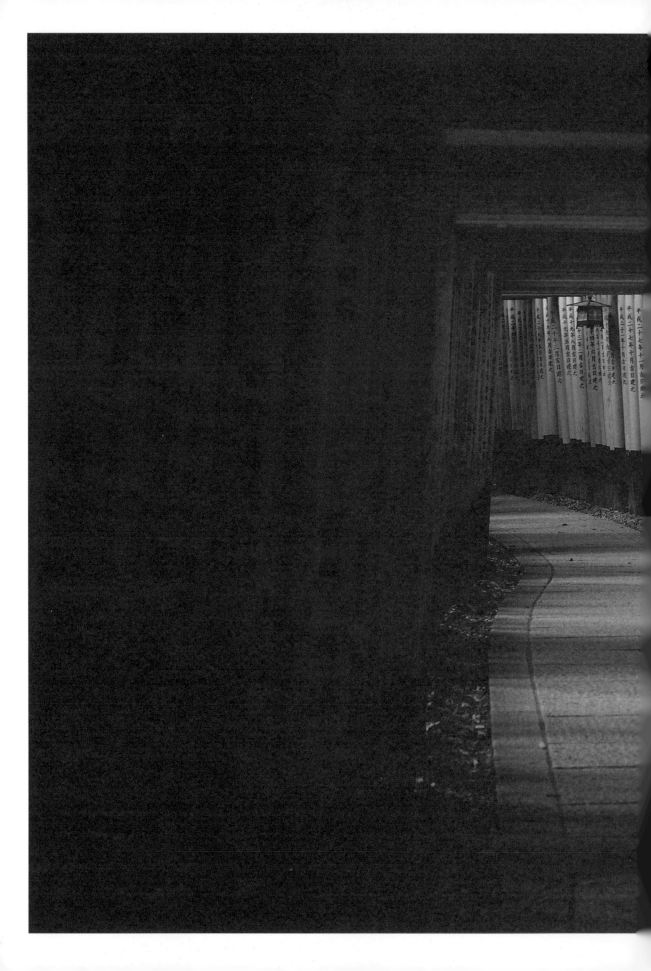

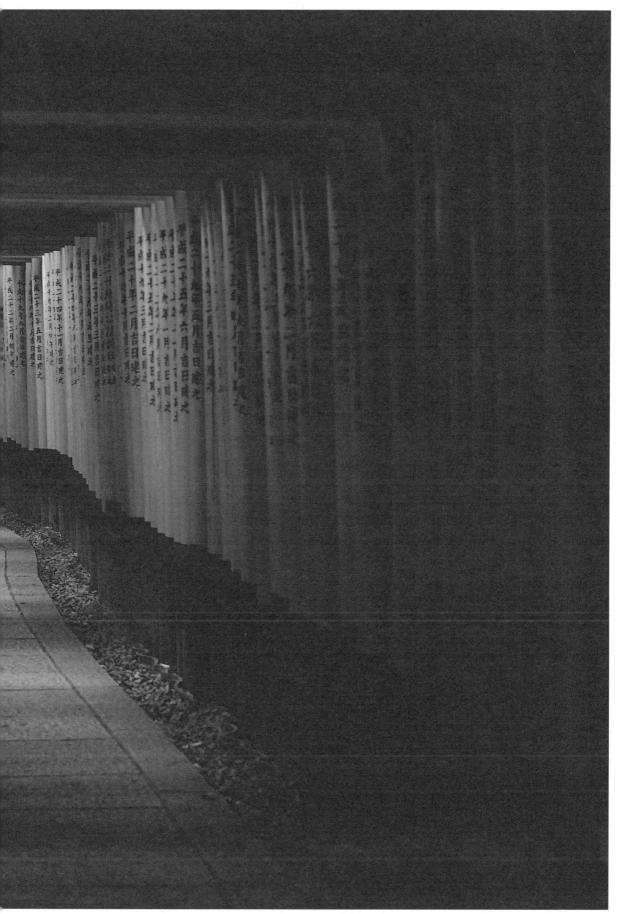

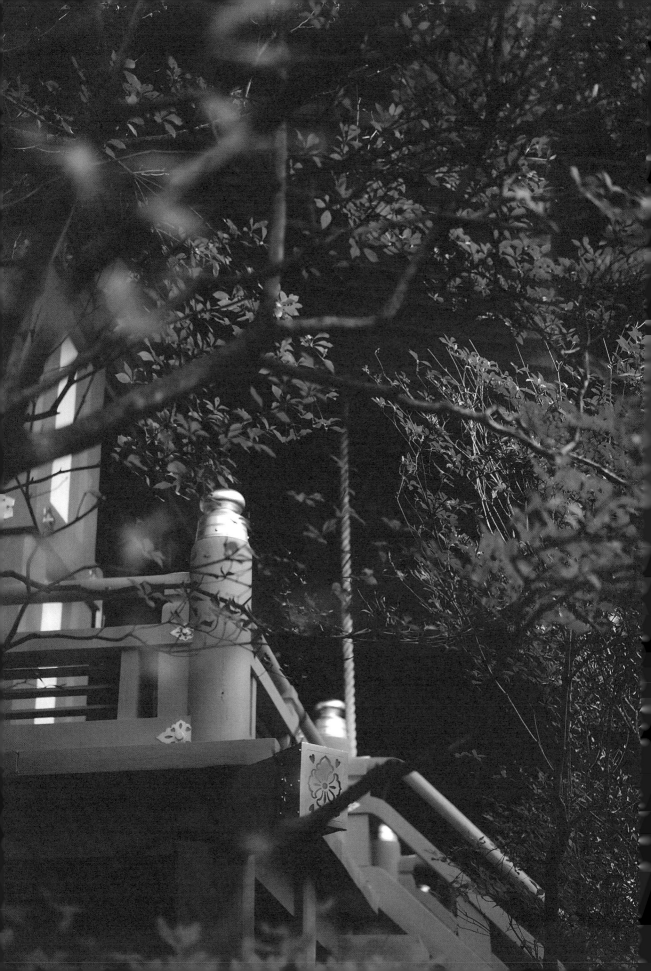

文ならぬ
いろはもかきて
火中哉

松尾　芭蕉

Though not words of

Passion, these matching colours are swept up

And consigned to the flames.

Bashō

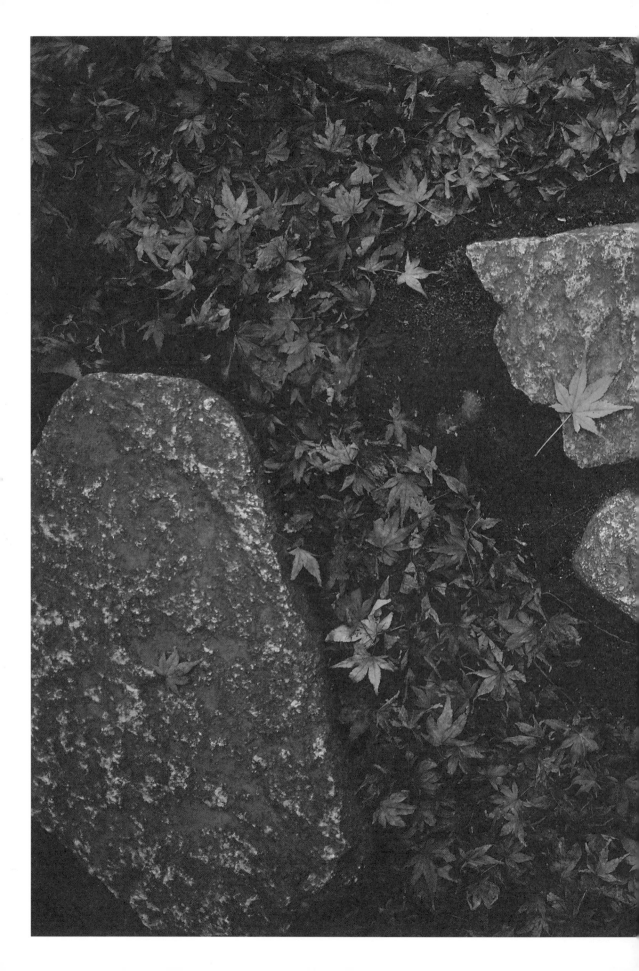

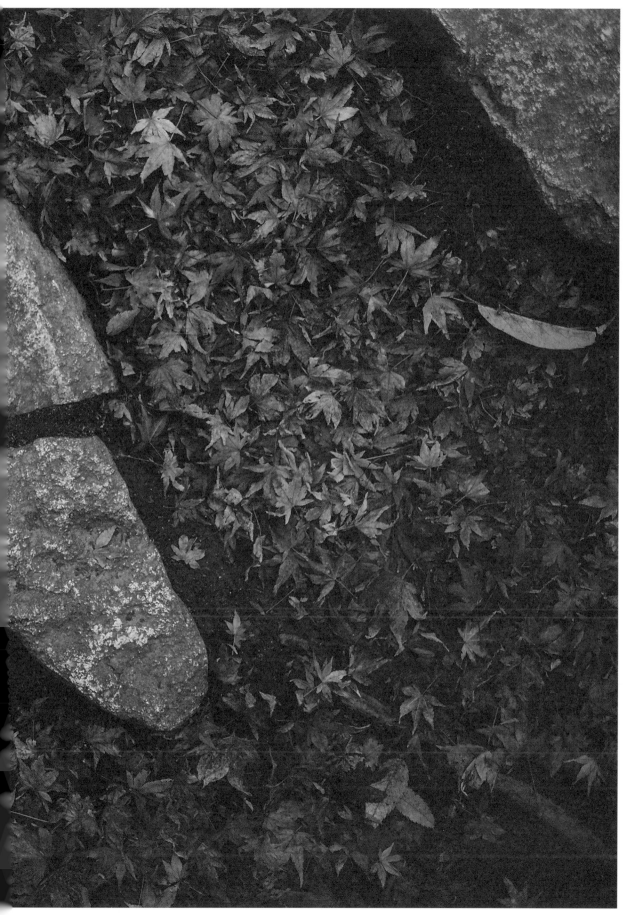

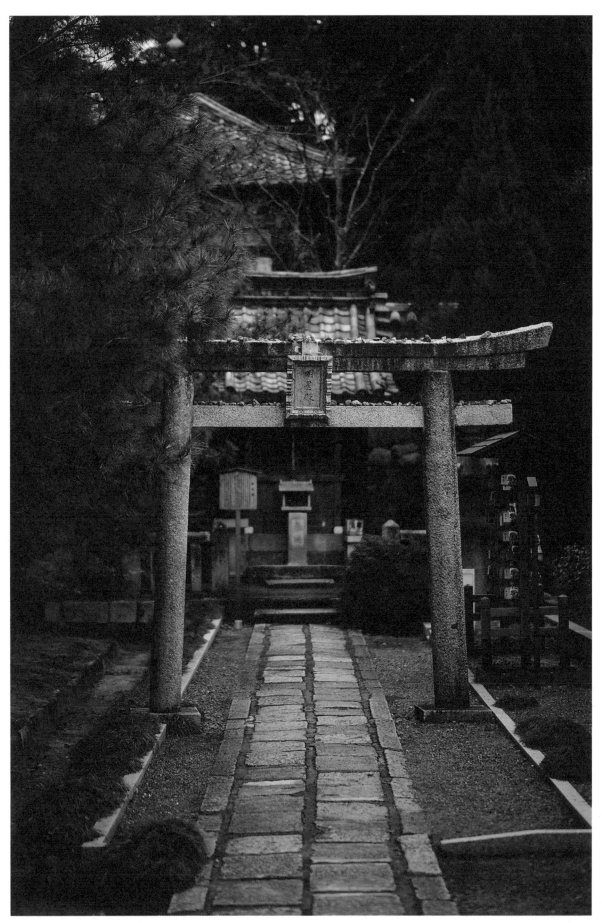

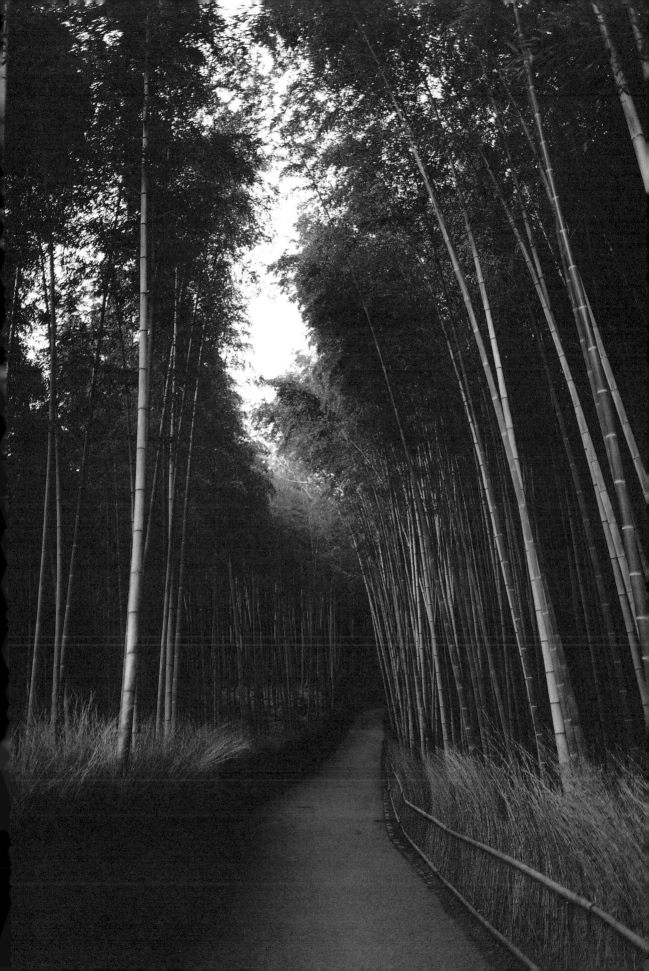

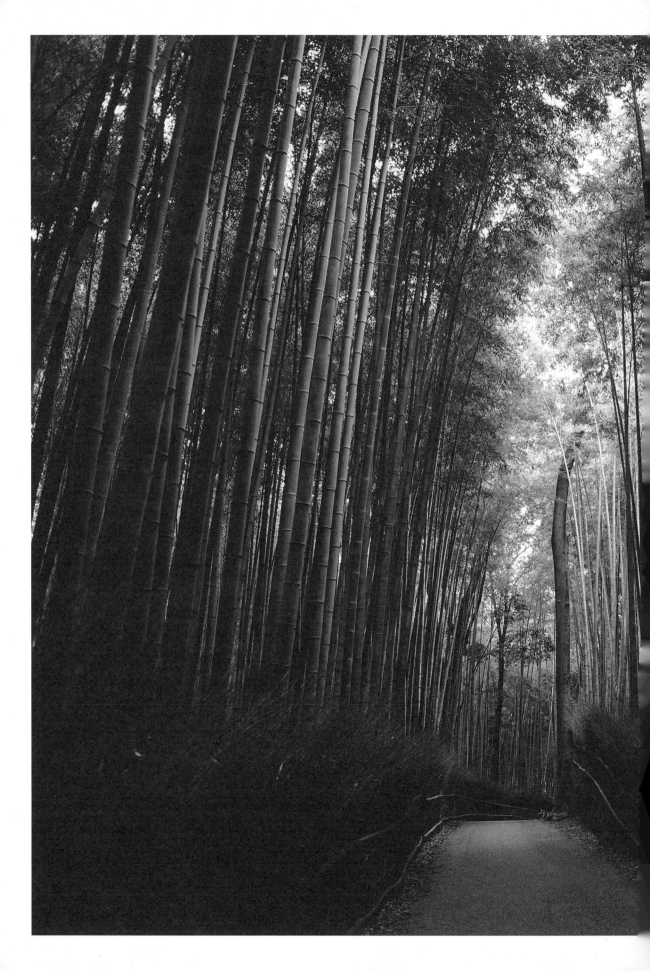

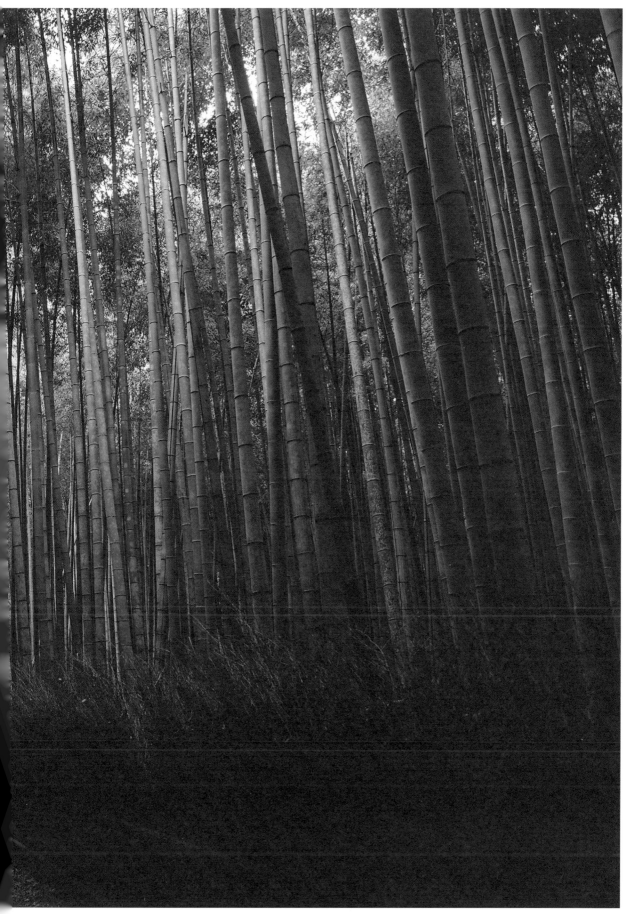

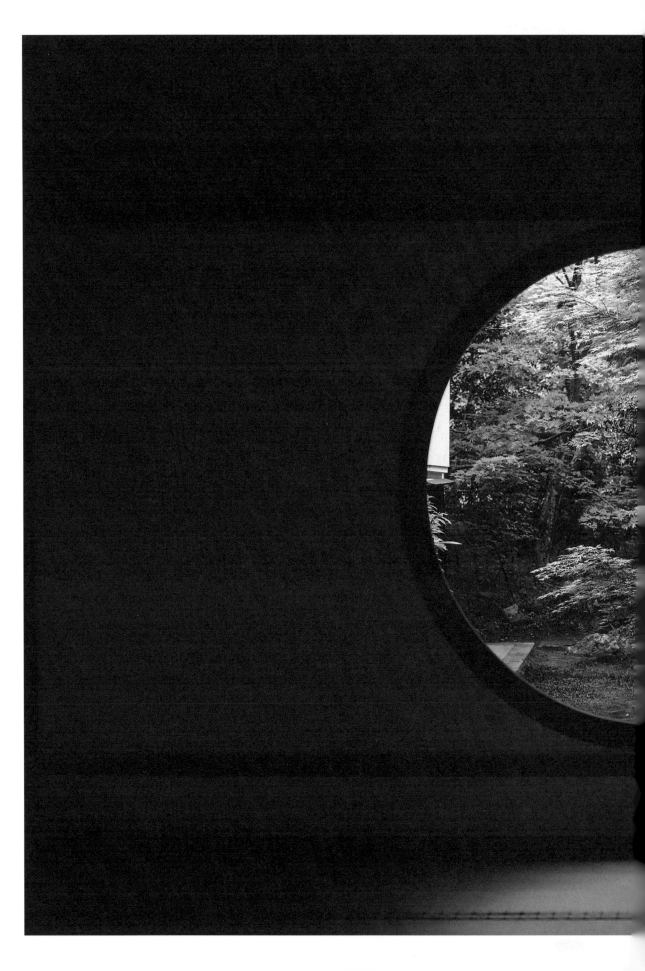

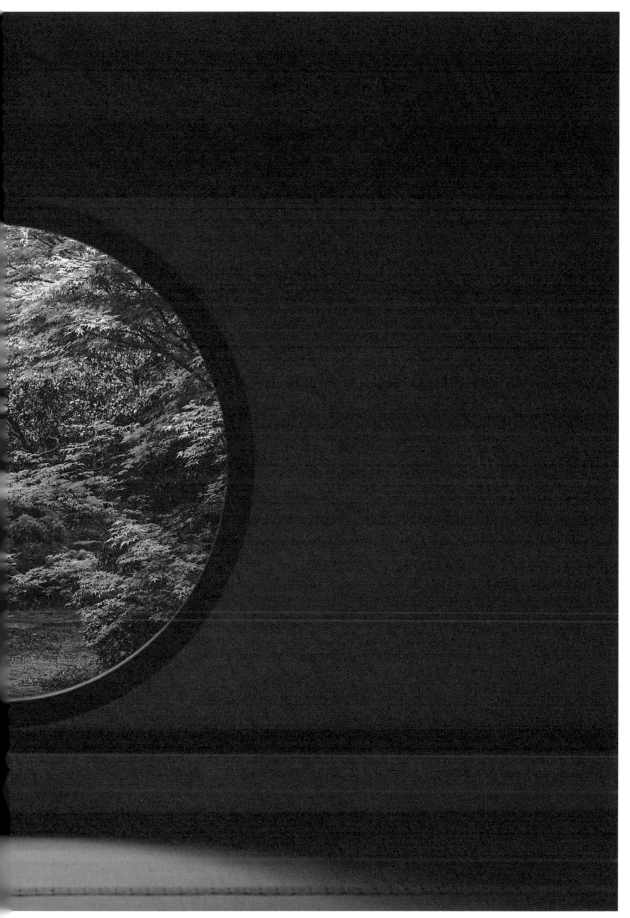

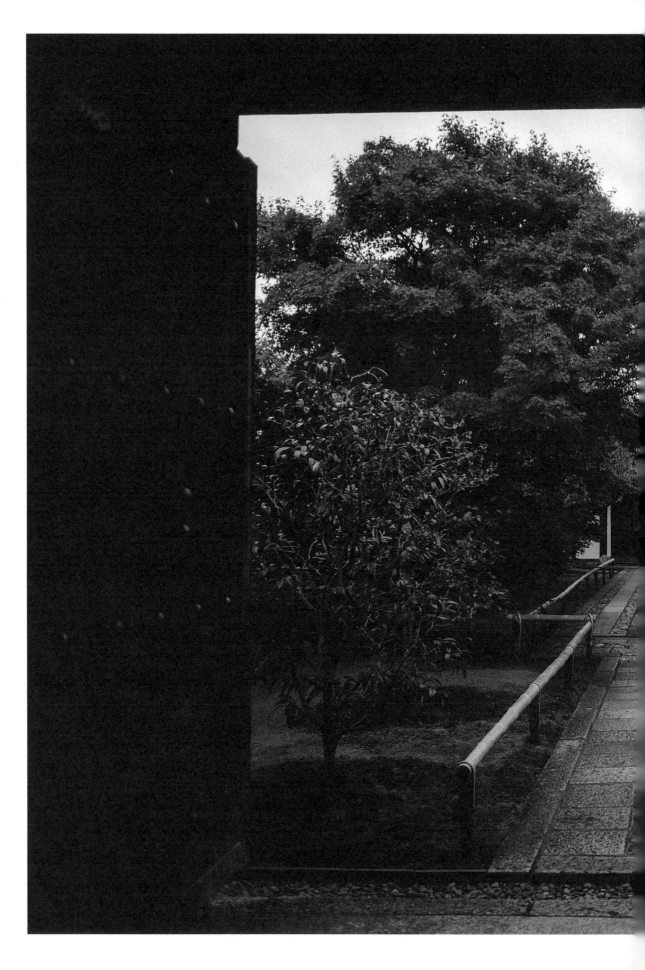

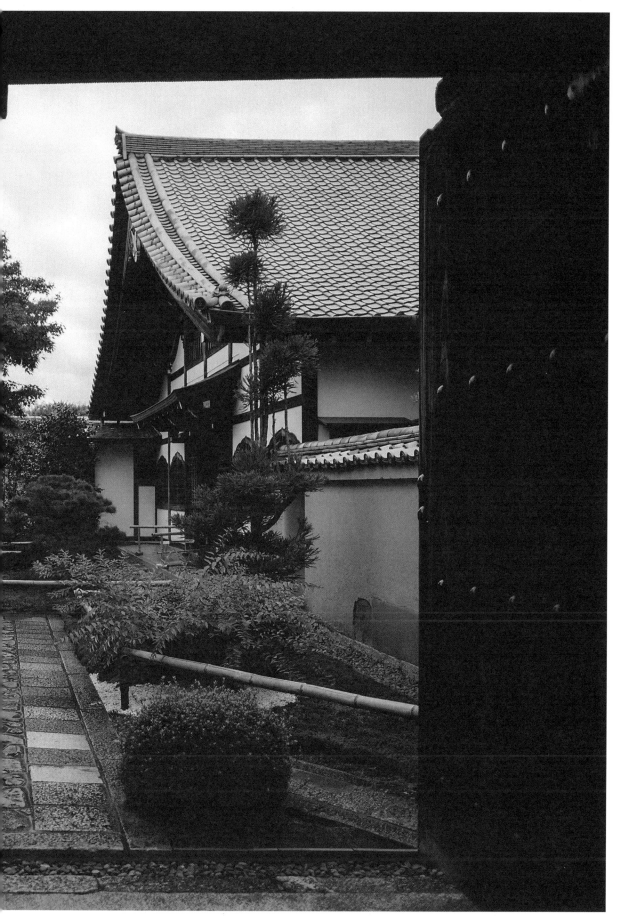

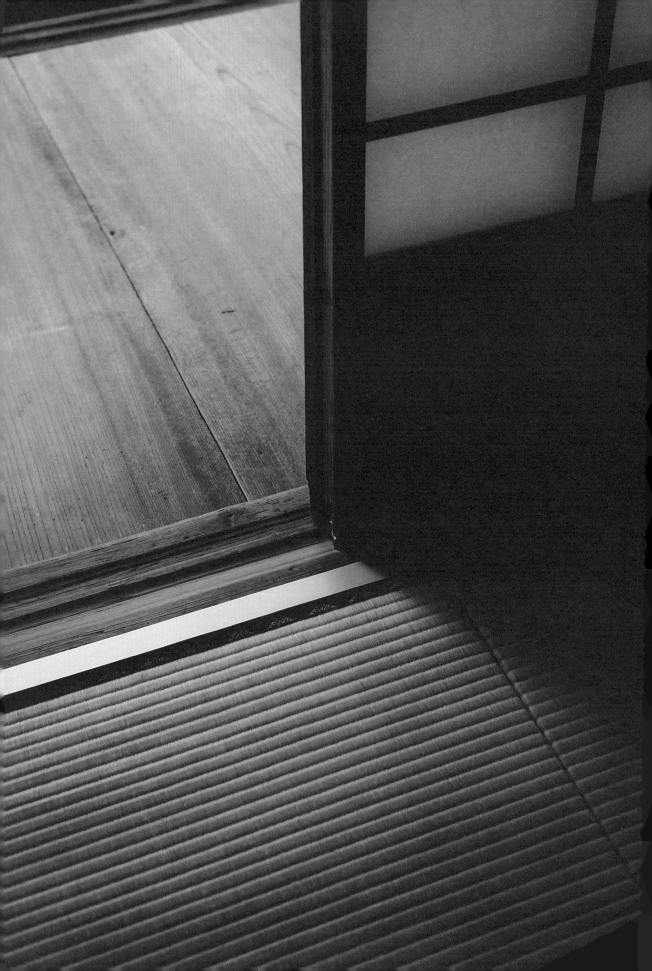

春風の
扉ひらけば
南無阿弥陀仏

種田 山頭火

spring wind —

when the doors open

namu amida butsu

Taneda Santōka

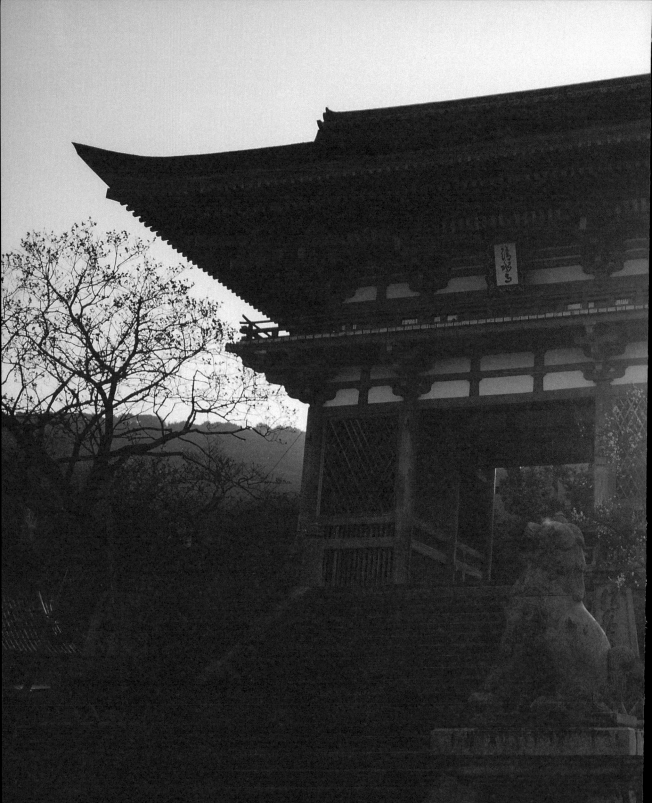

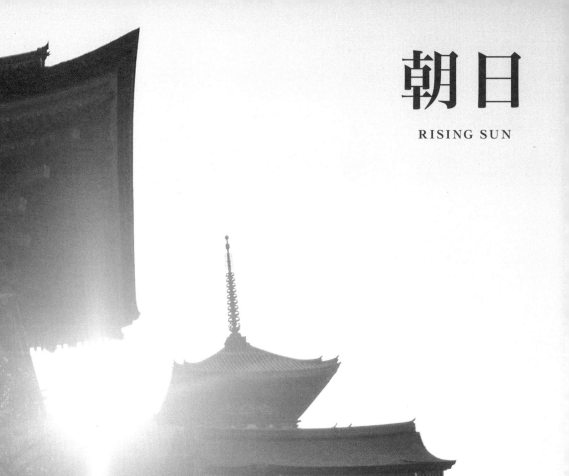

朝日

RISING SUN

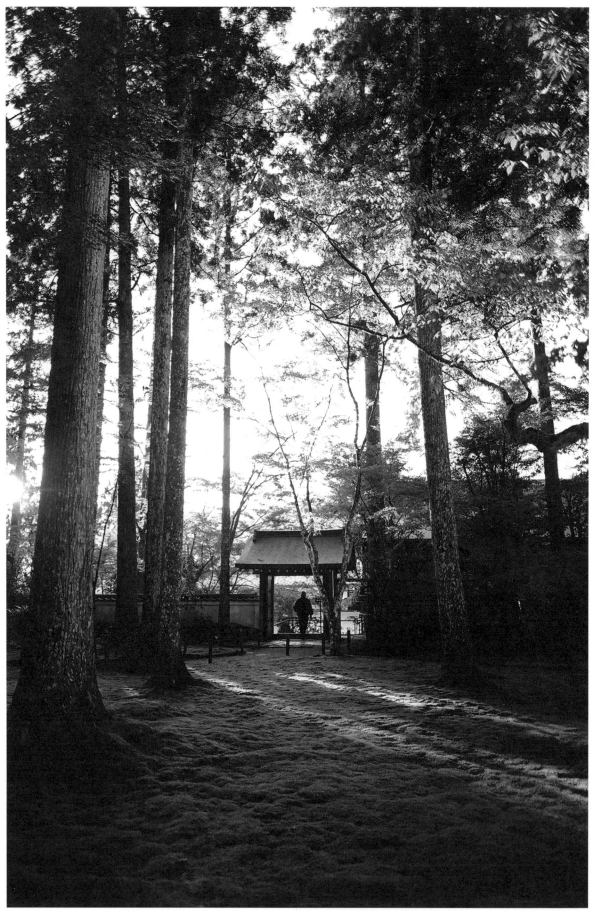

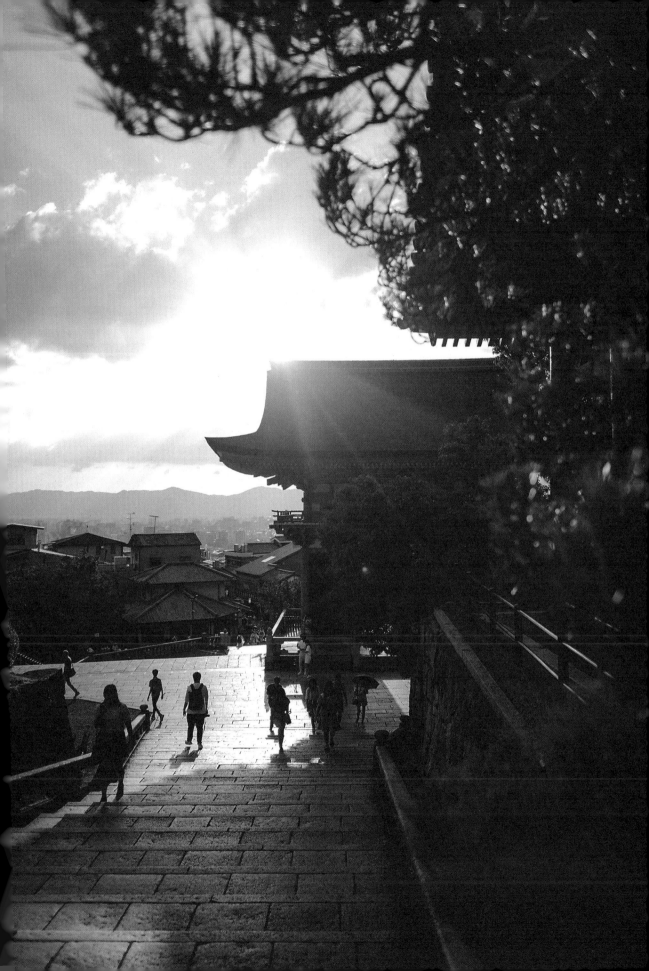

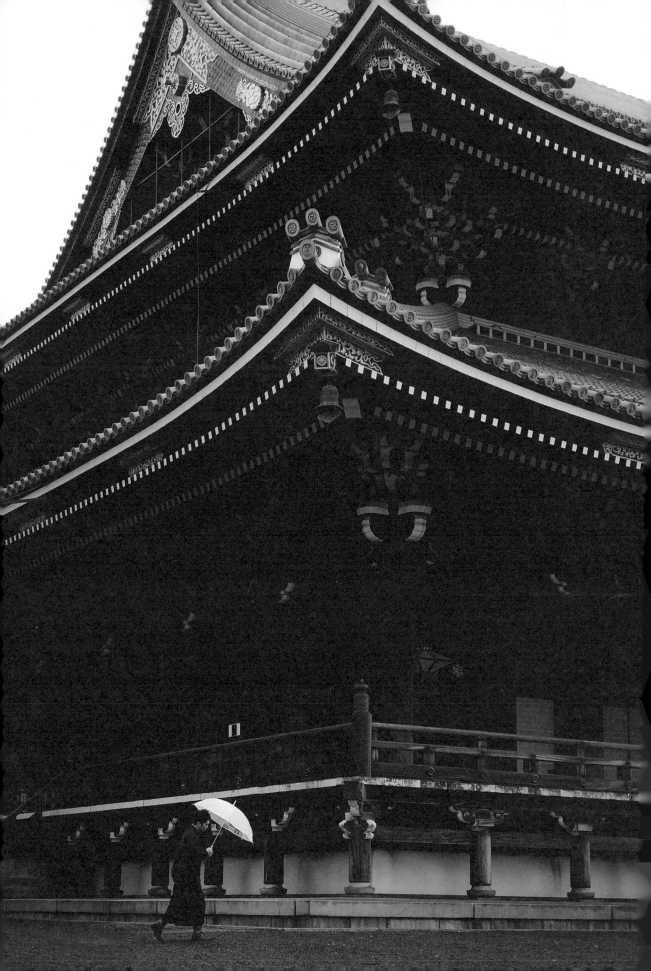

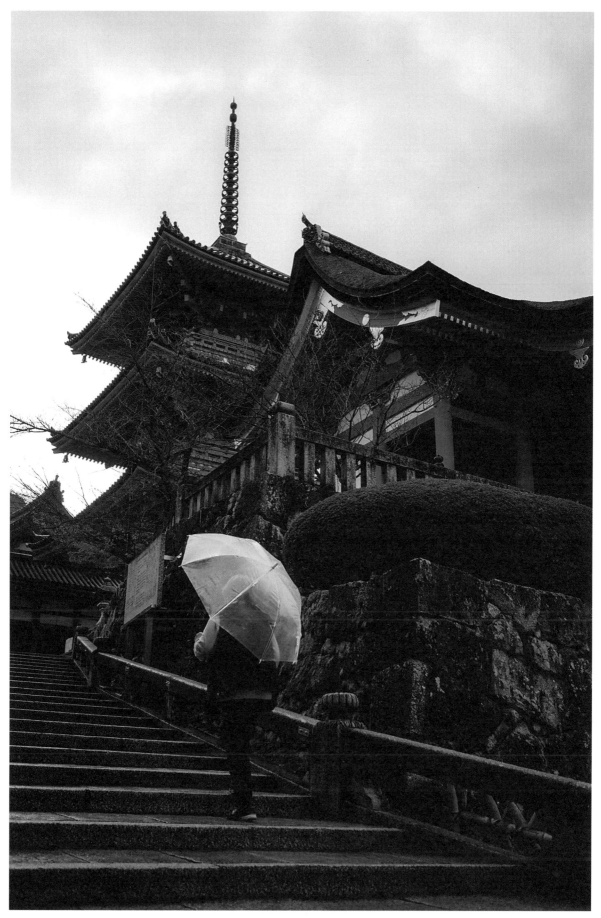

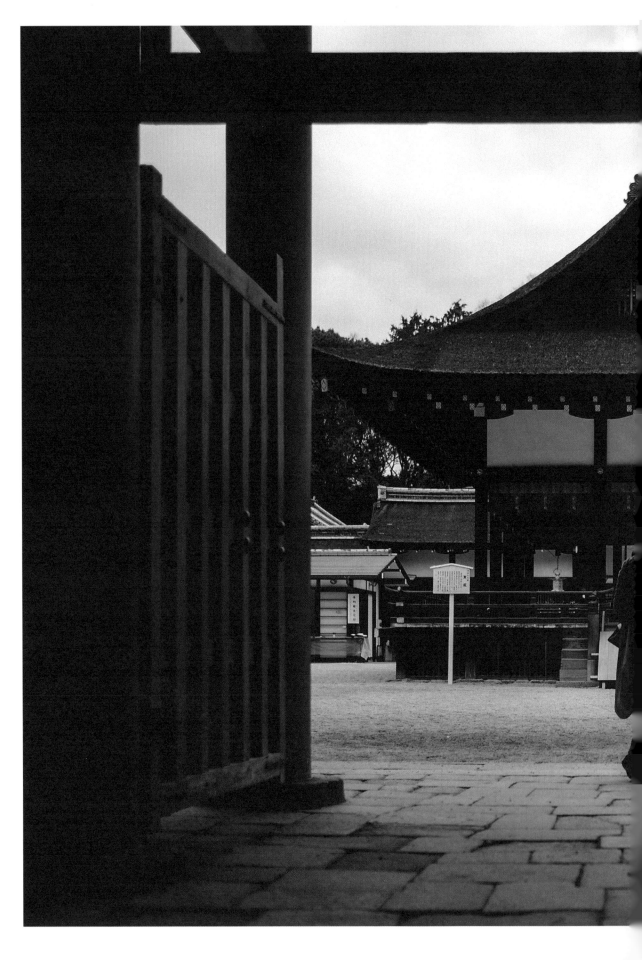

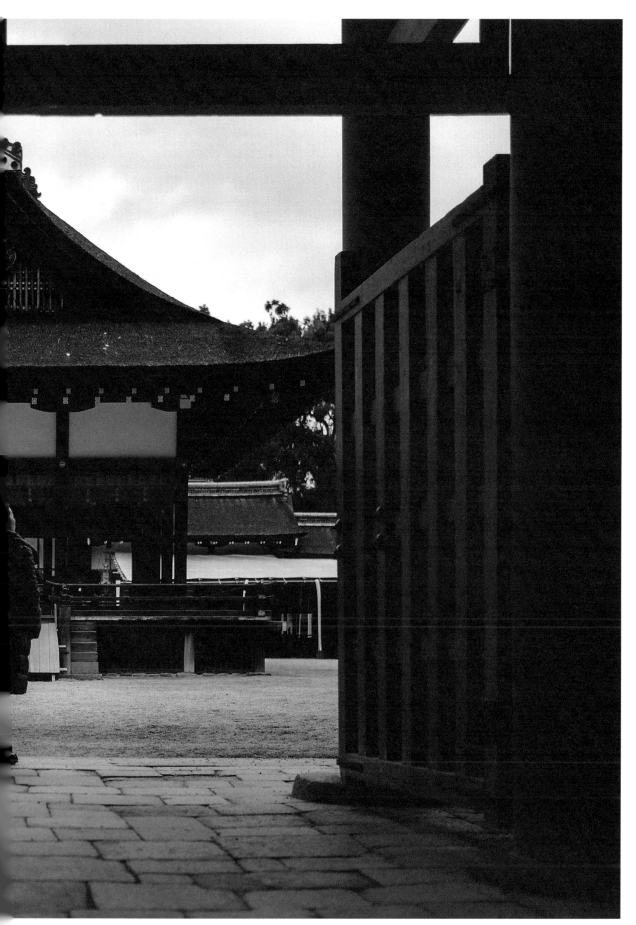

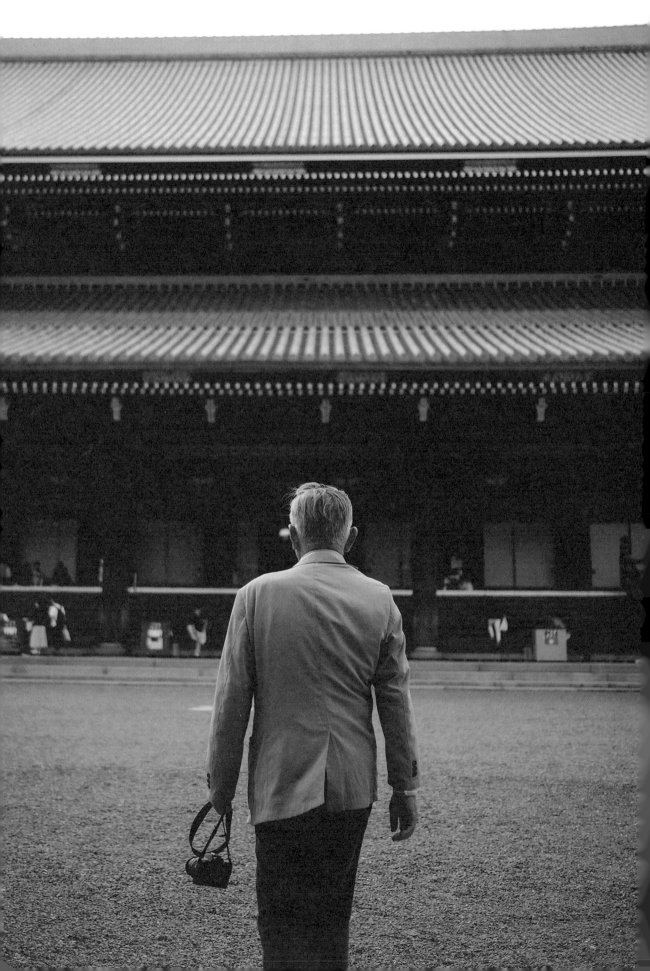

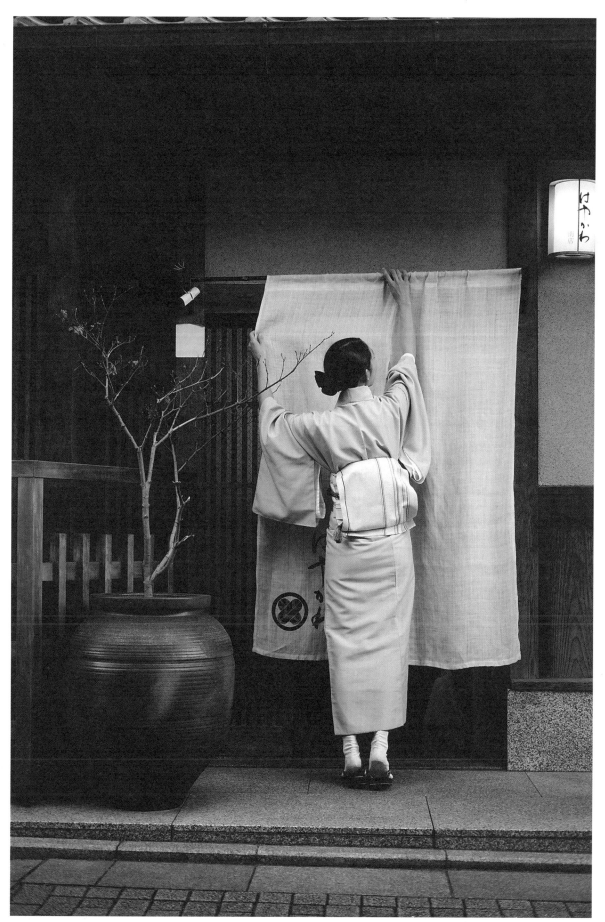

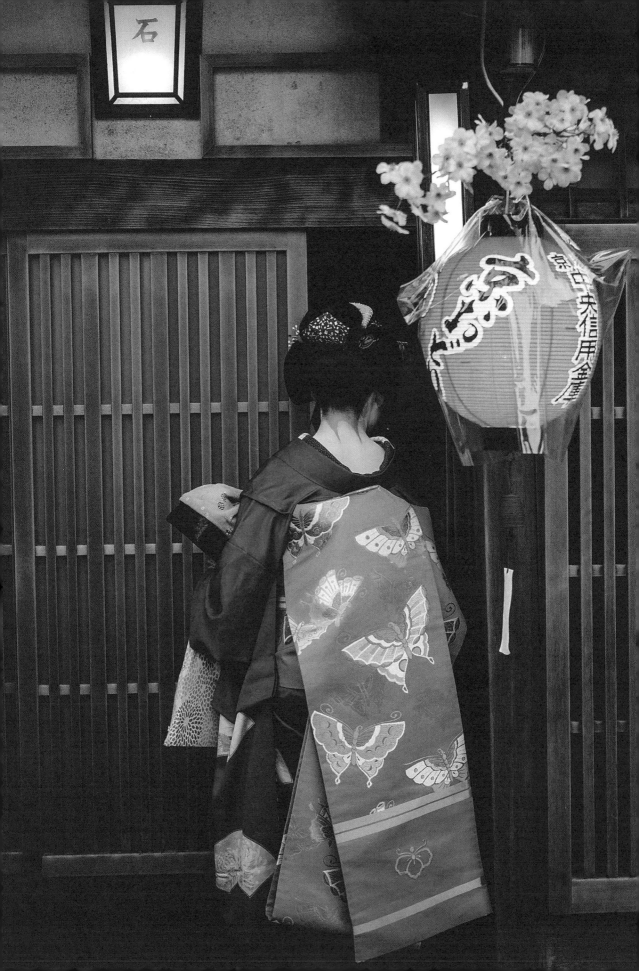

京にても
京なつかしや
ほとゝぎす

松尾 芭蕉

Now I am in the Capital

It seems so dear to me,

O, cuckoo.

Bashō

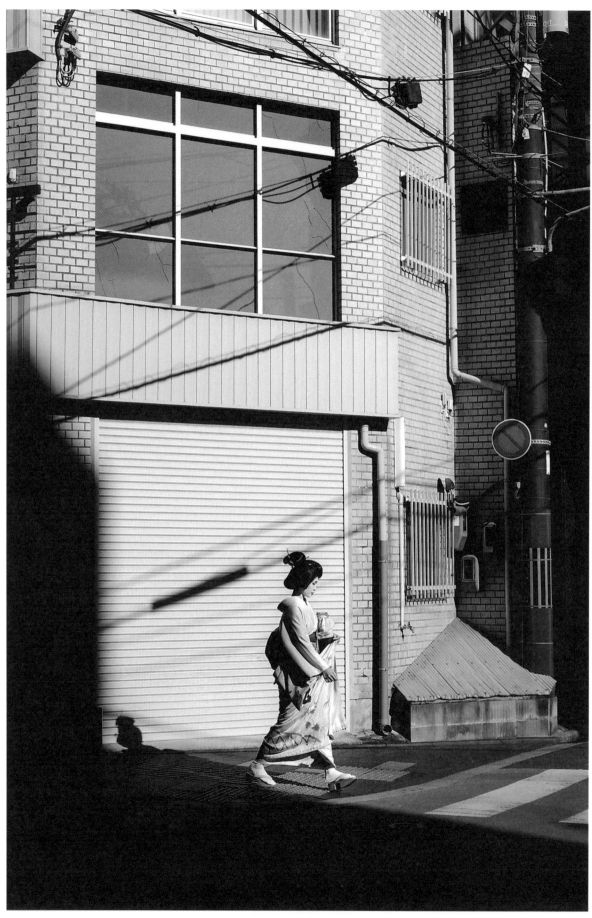

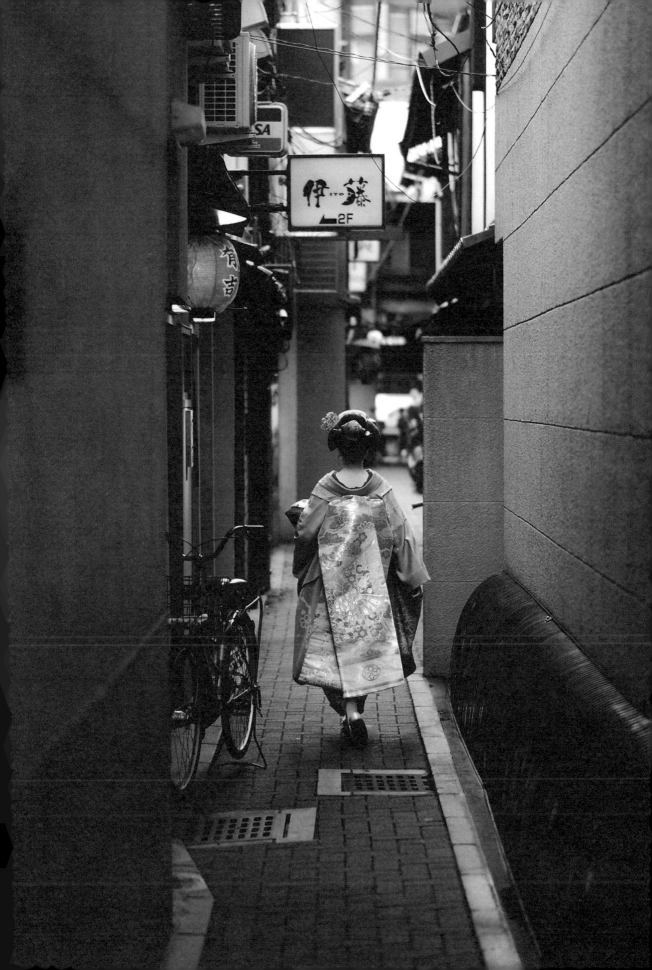

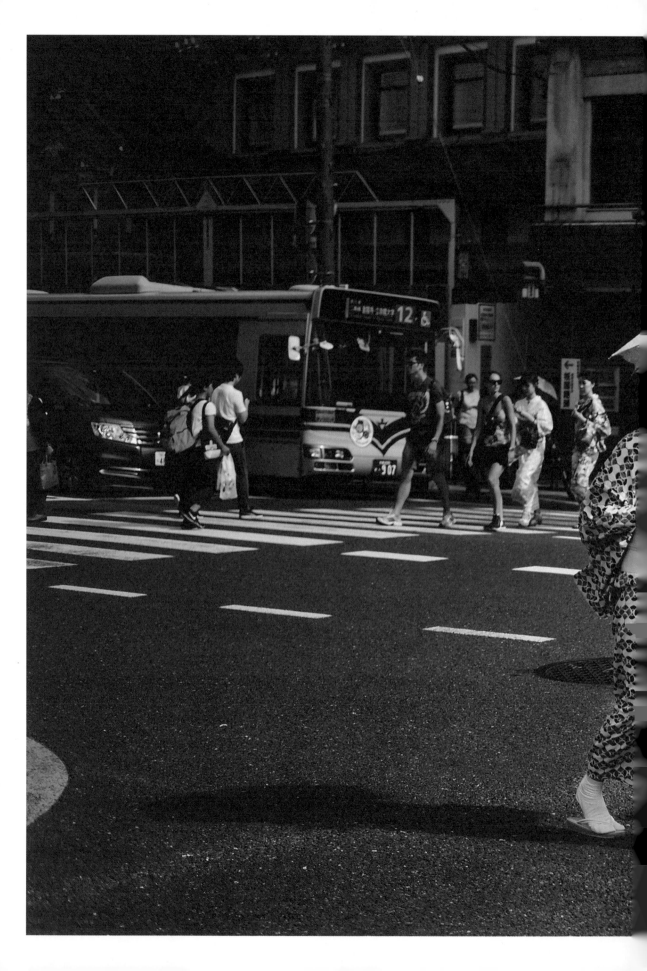

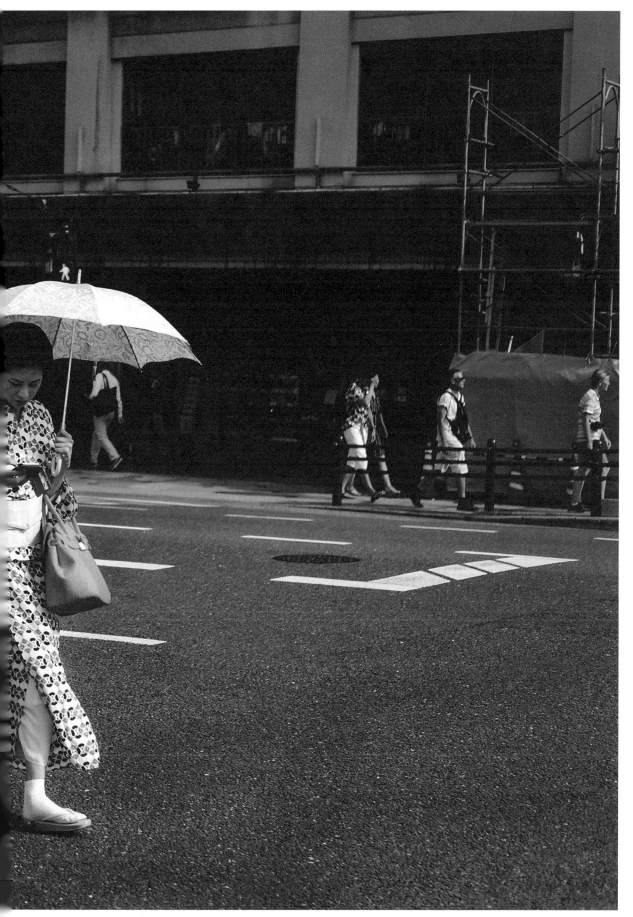

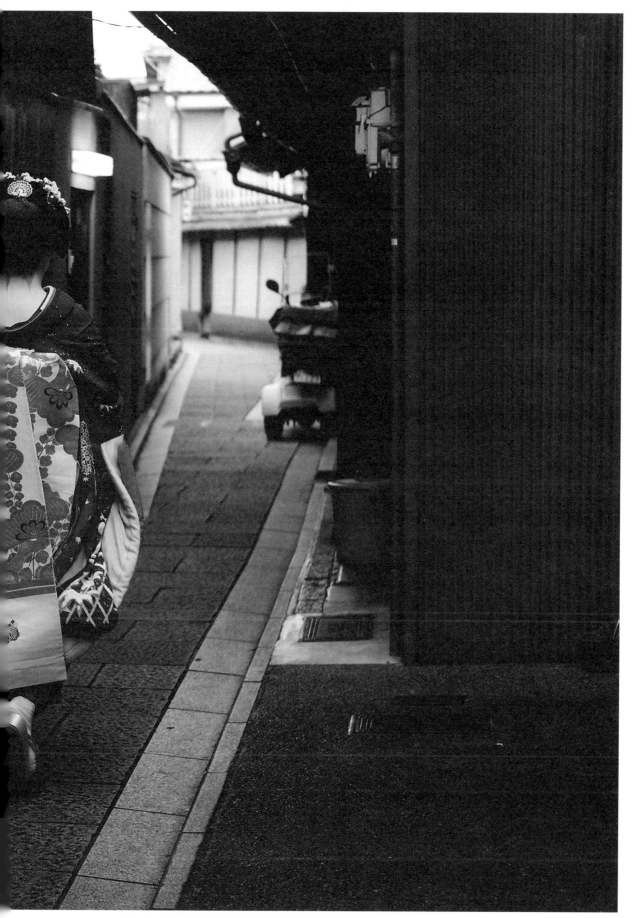

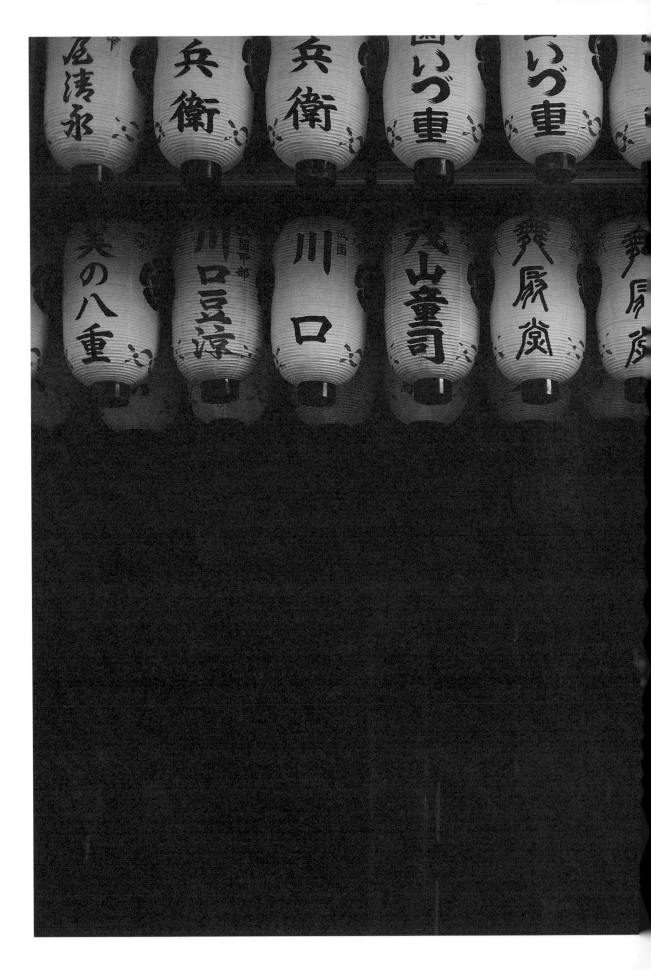

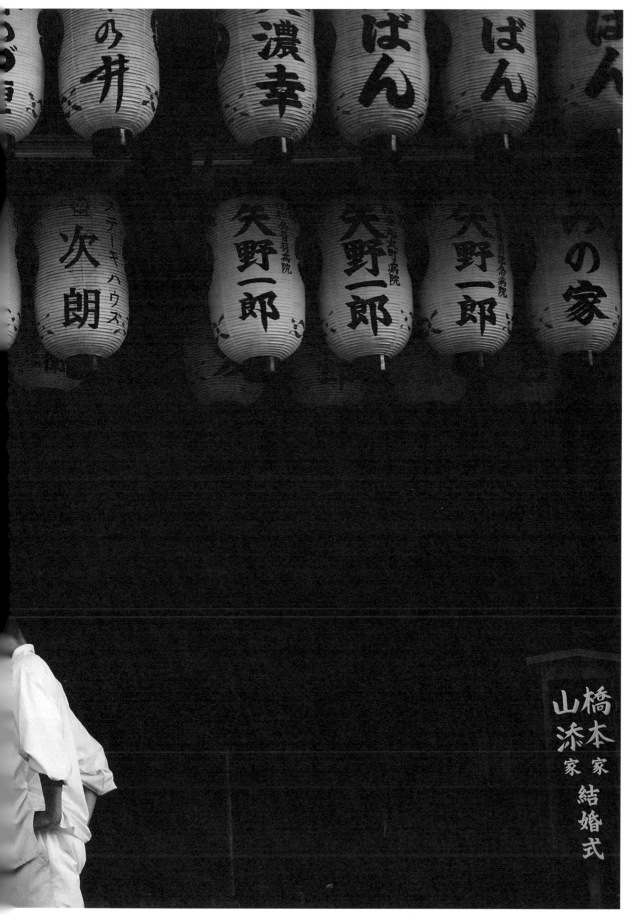

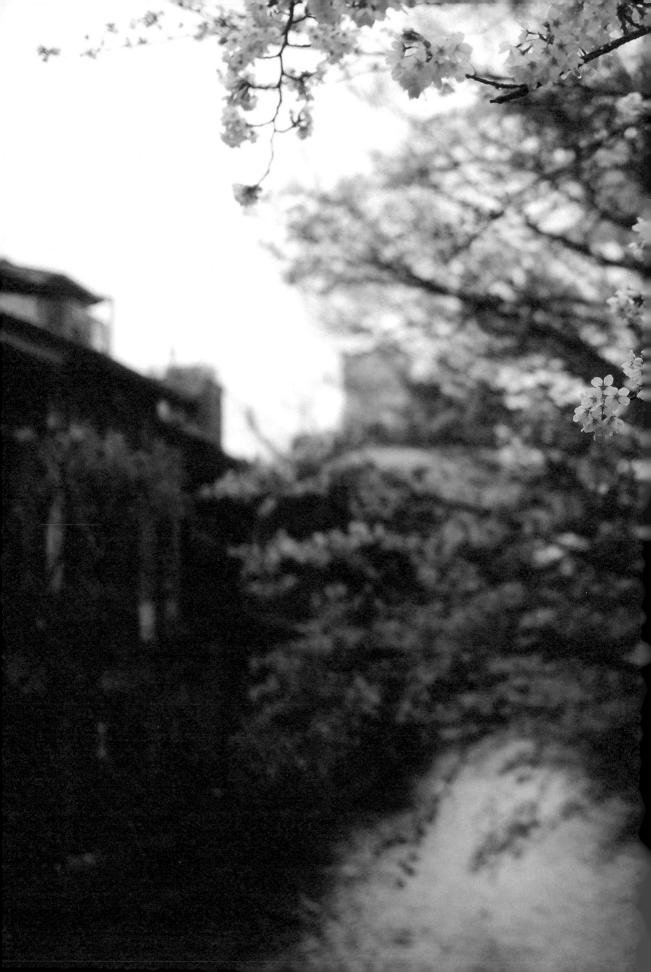

SAKURA

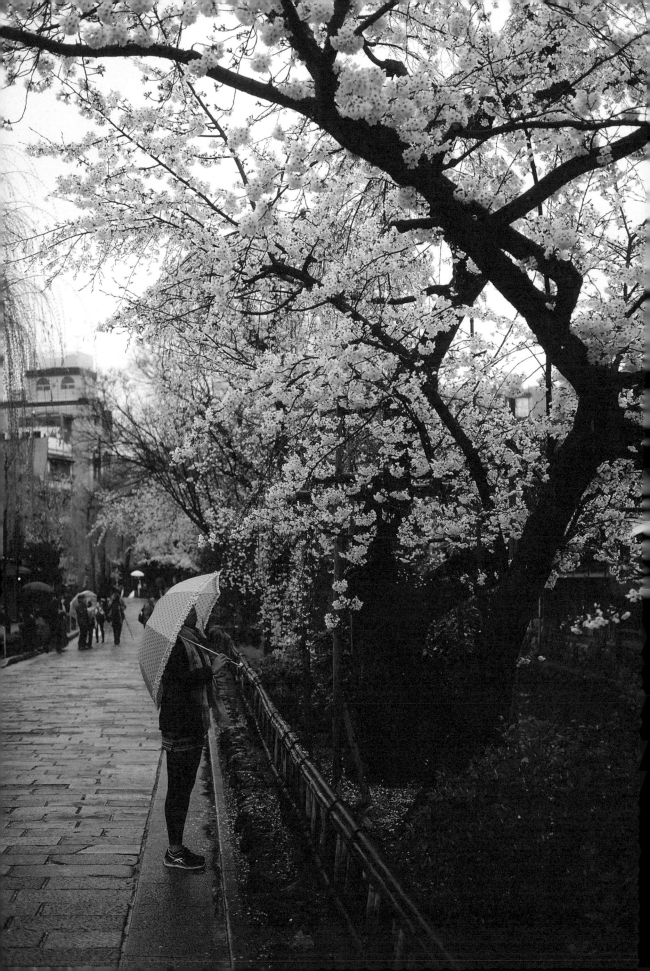

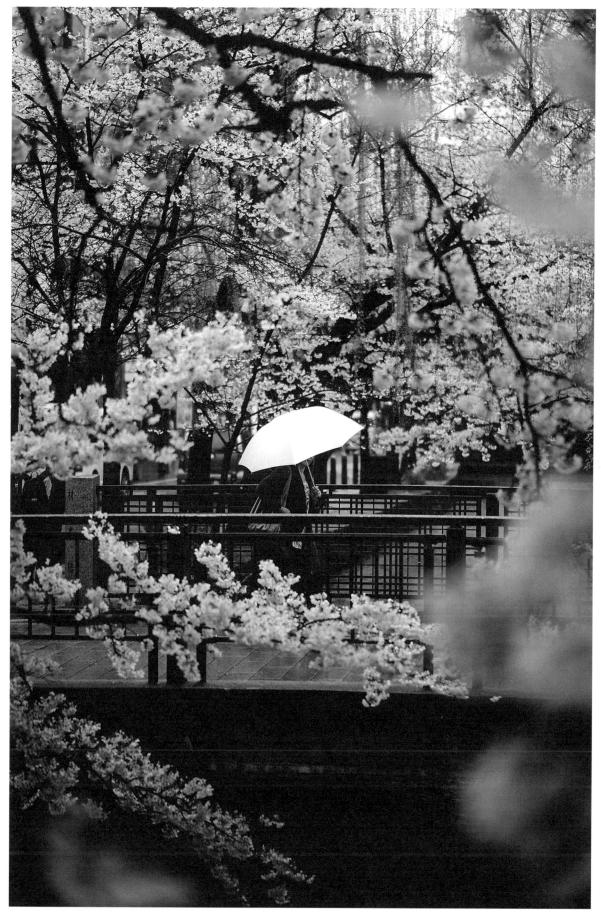

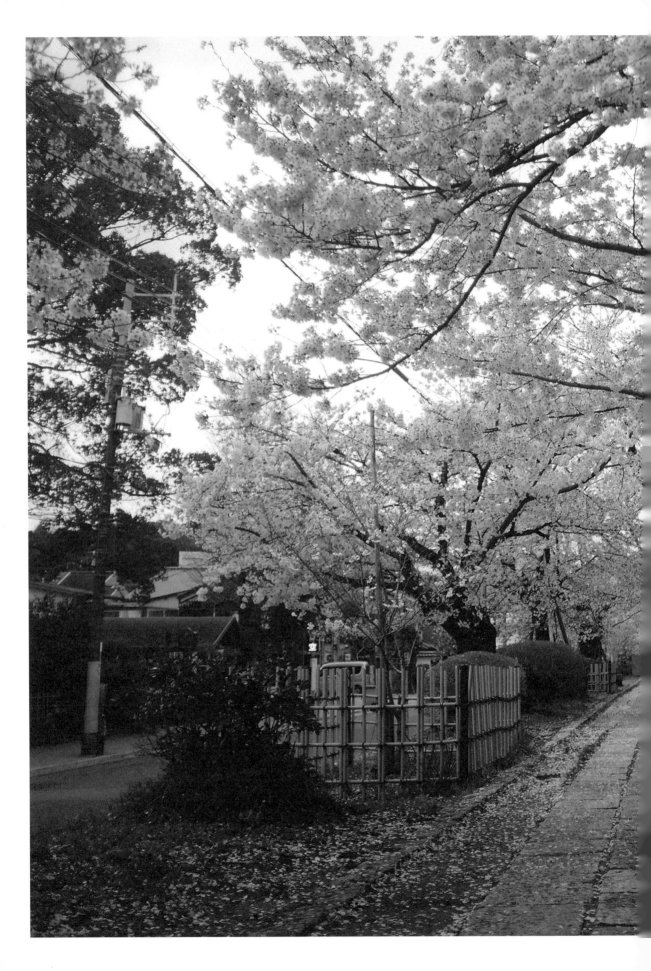

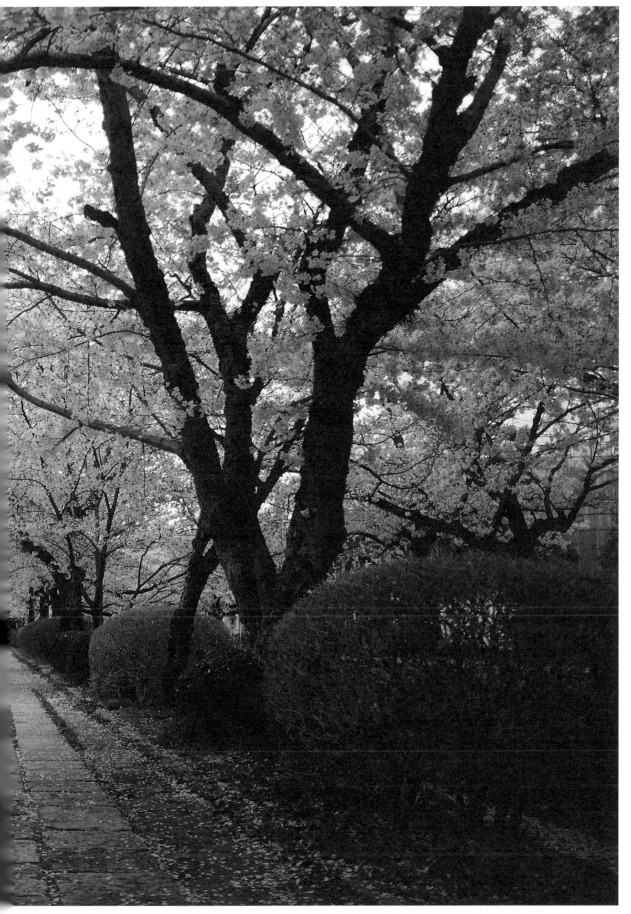

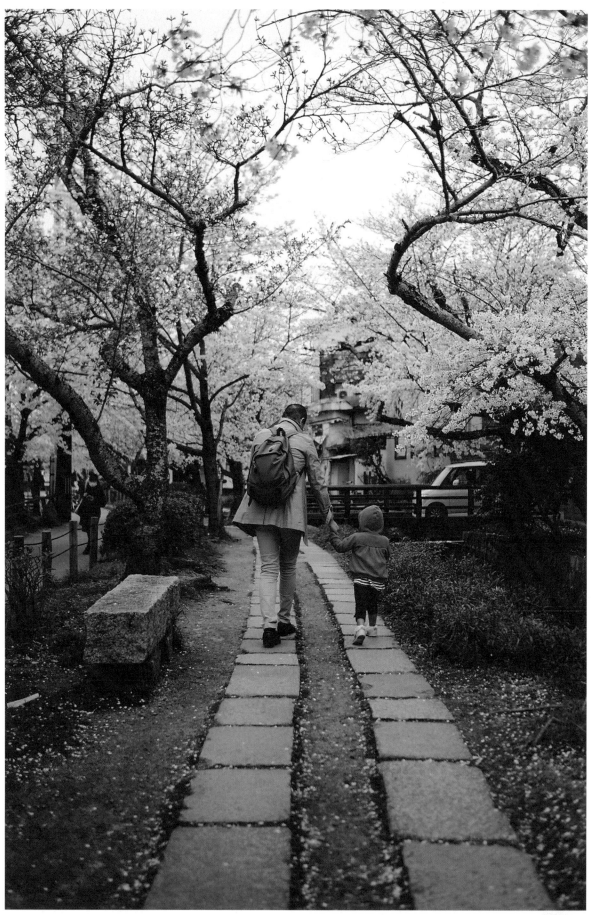

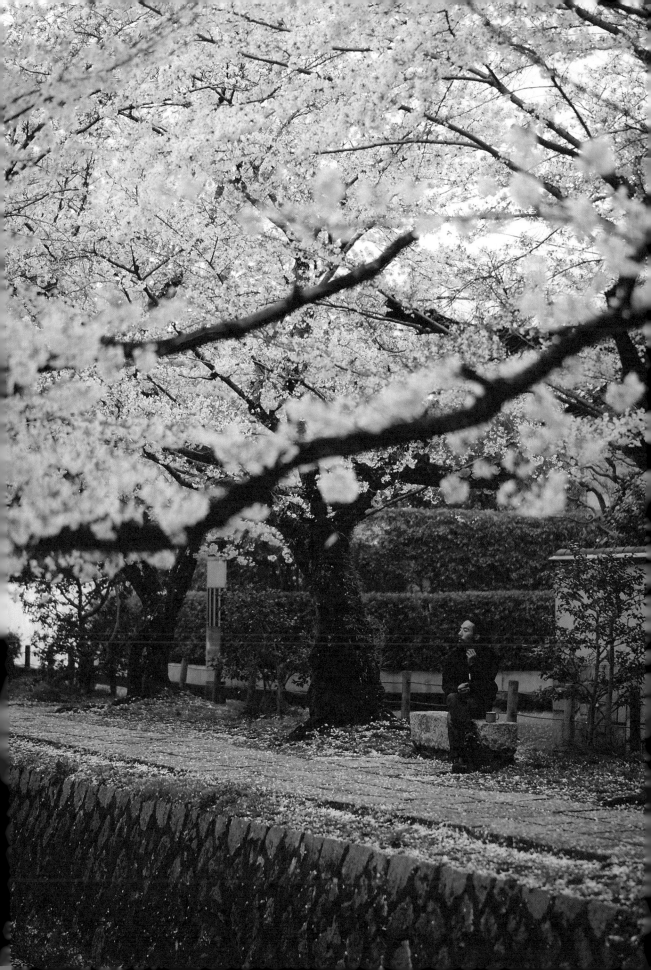

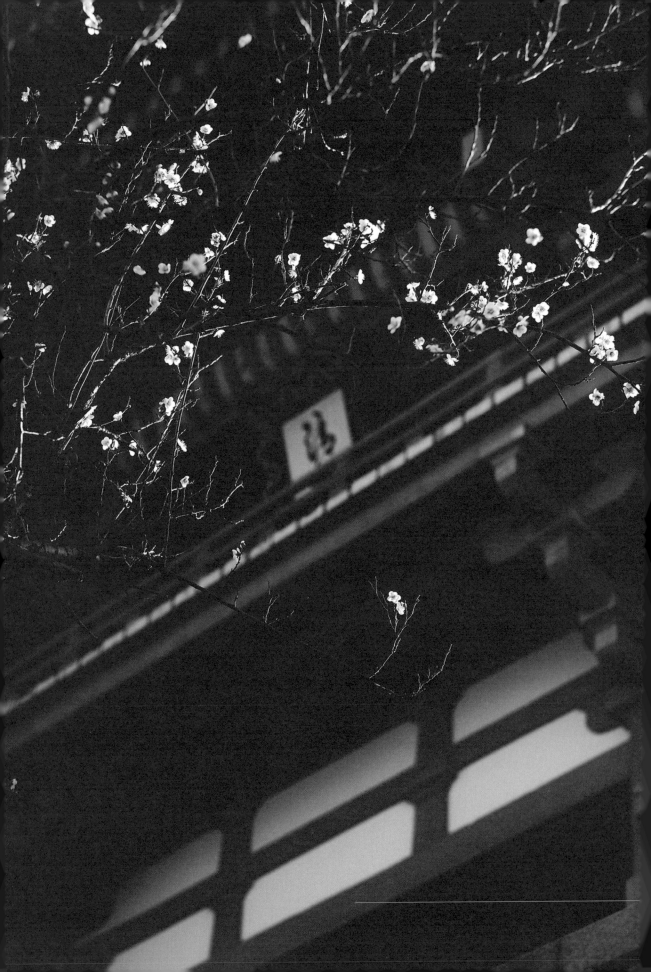

咲きてとく散るは
憂けれど行く
はる花の都を
たちかへりみよ

紫式部

Petals bloom then scatter

a sorrowful spring parting

but you will surely come again

to view the flowering capital

Murasaki Shikibu

excerpt from *The Tale of Genji*

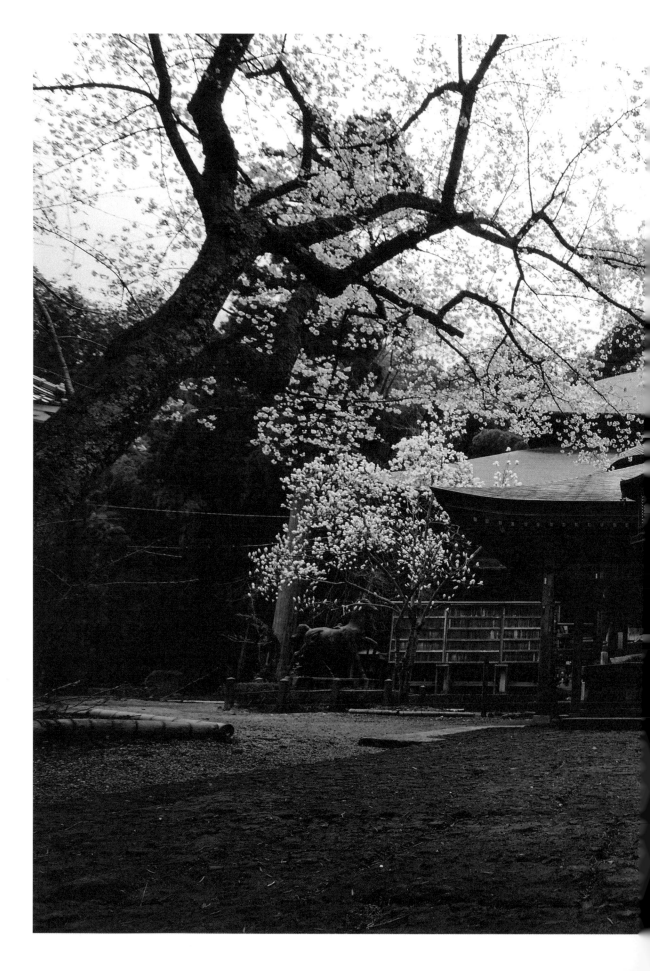

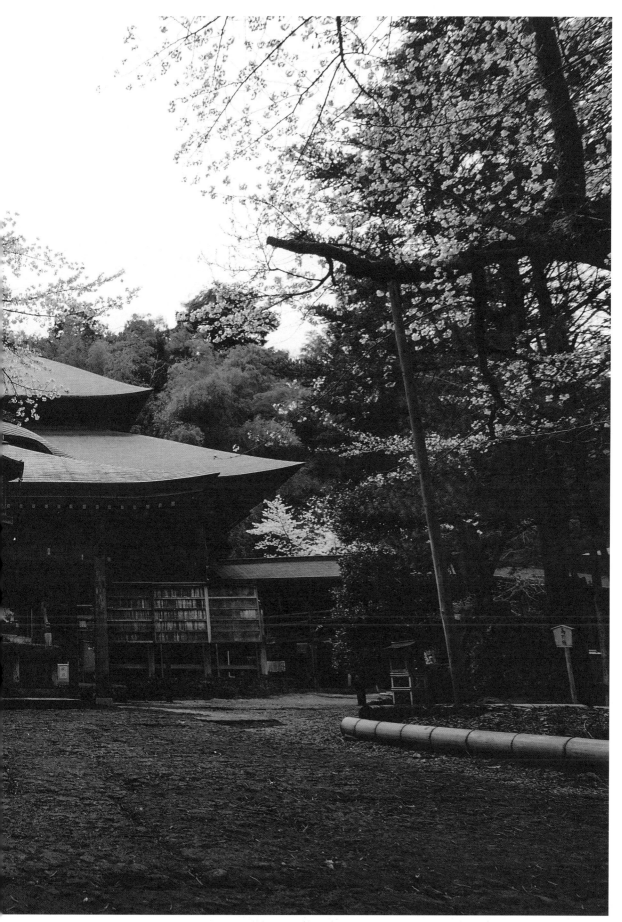

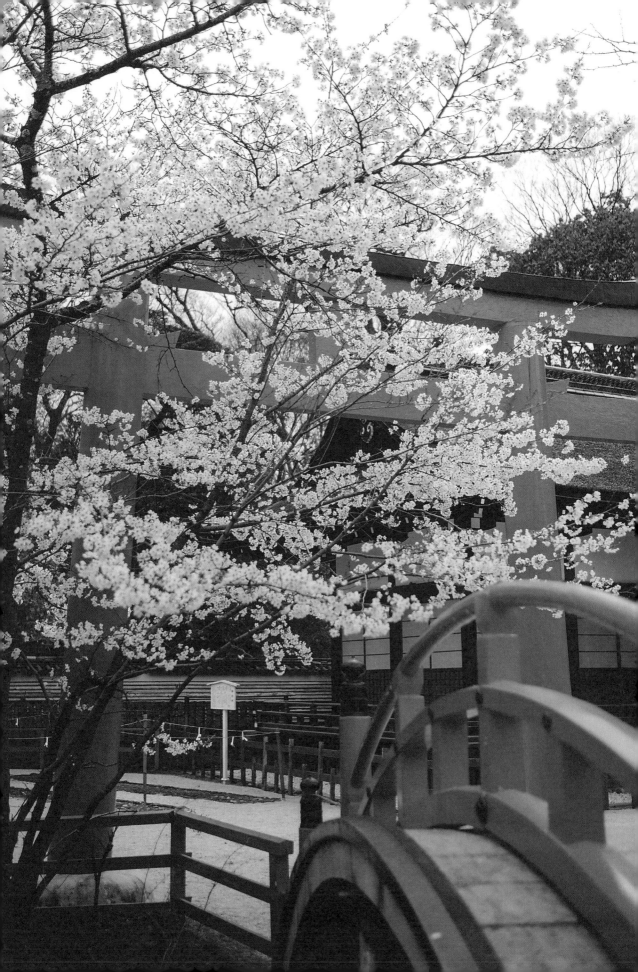

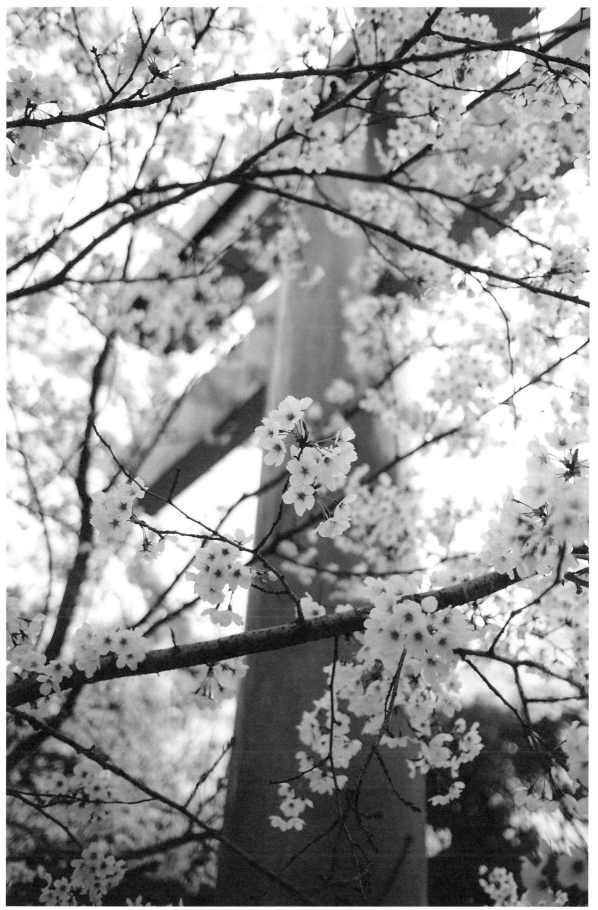

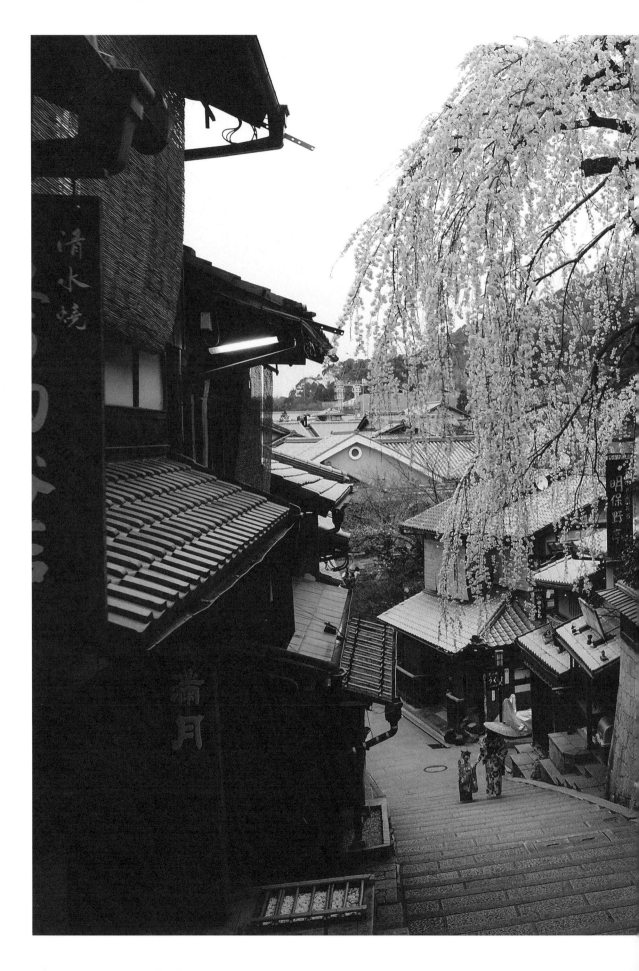

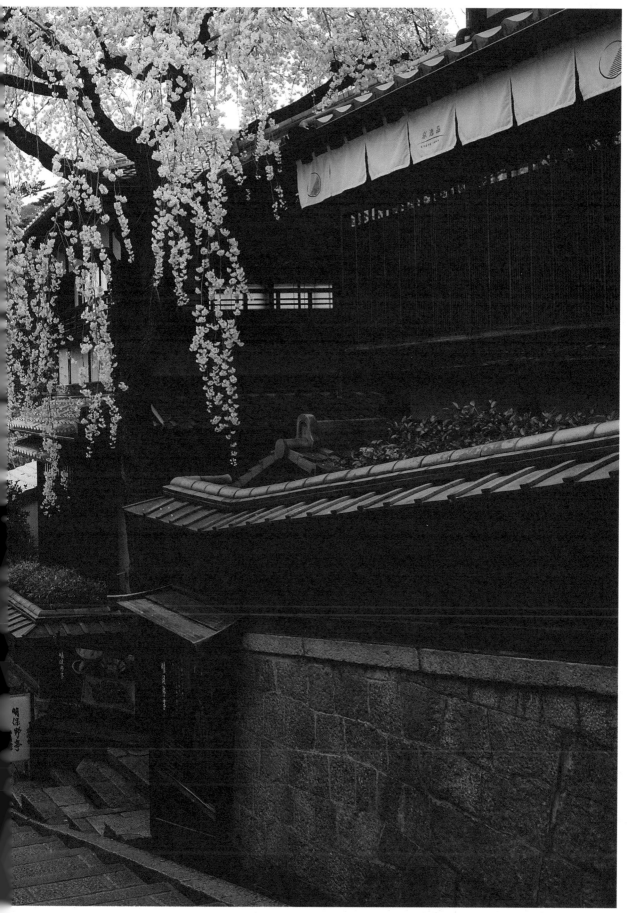

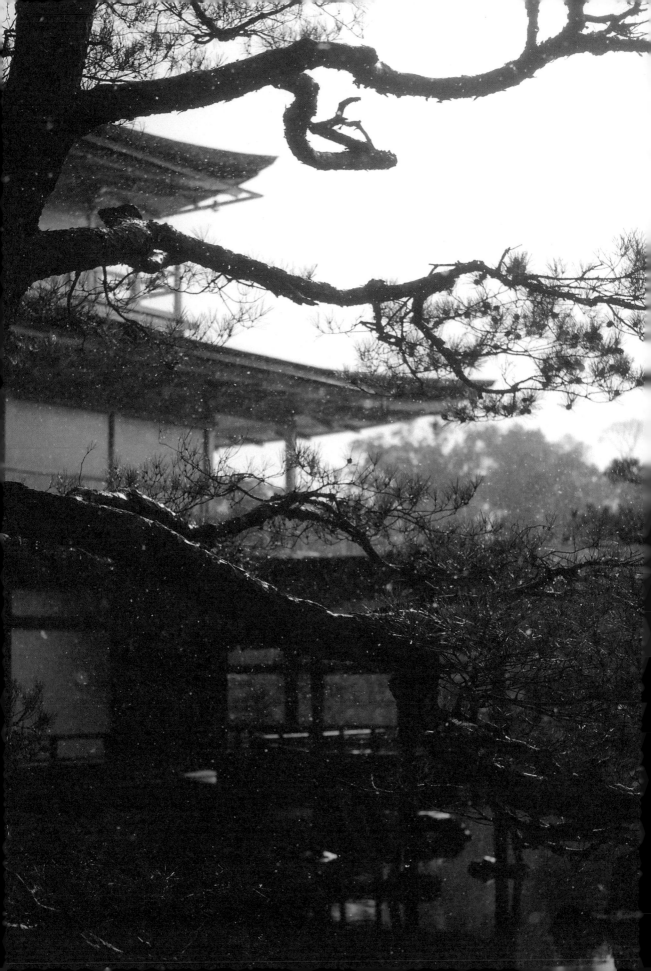

一夜さに
櫻はさゝら
ほさら哉

小林 一茶

Within but a single night

The cherry blossoms vanish

And are completely gone.

Kobayashi Issa

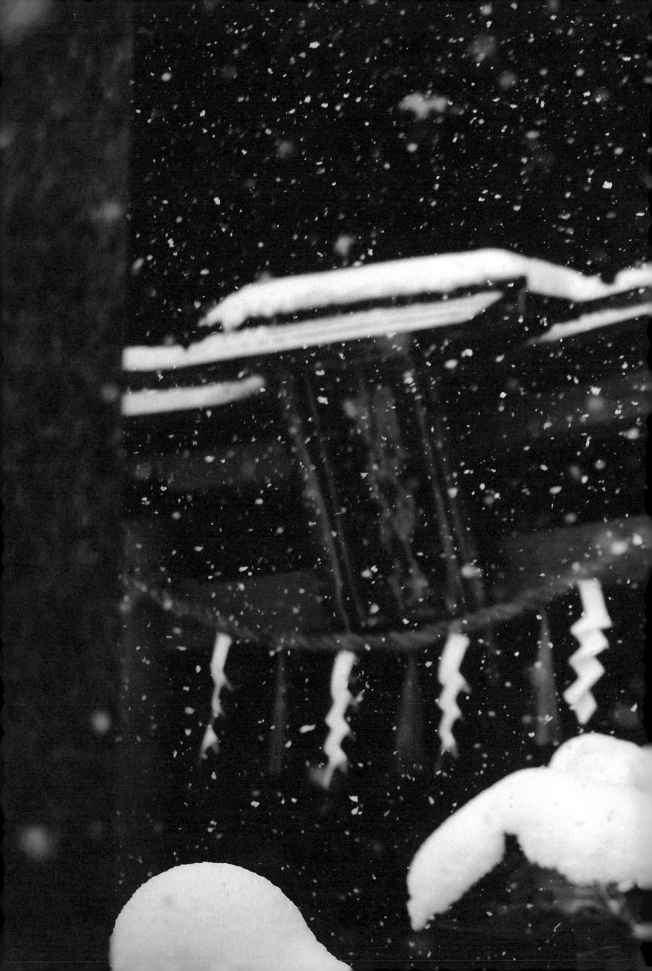

雪
SNOW

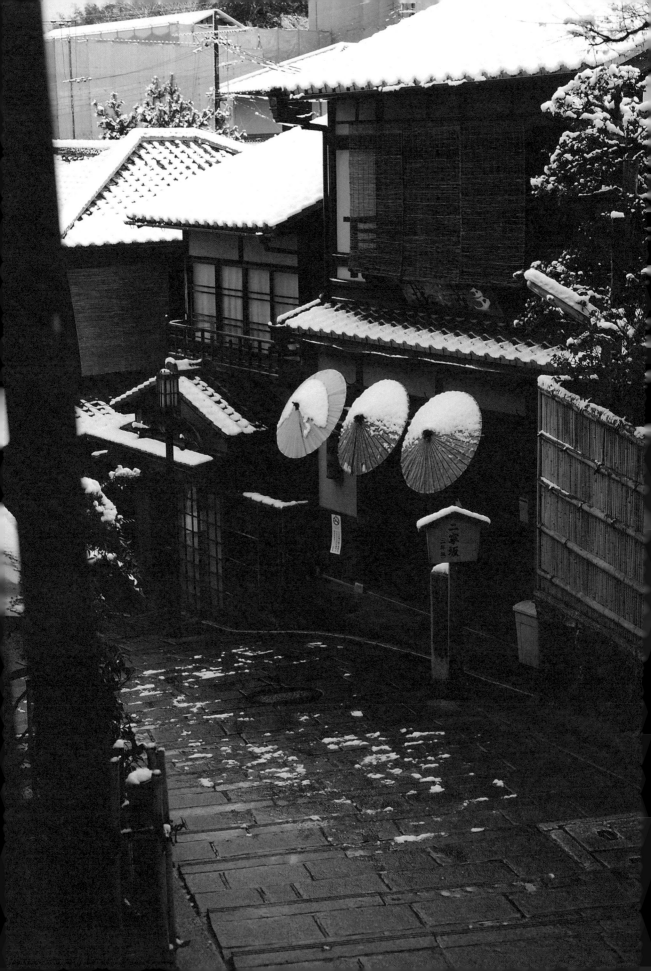

わが死なむ
日にも斯く降れ
京の山しら雪たかし
黒谷の塔

富子　山川

On the day that I die

may it fall like this —

white snow piled high

on the hills of Kyoto

and Kurodani's dark pagoda

Yamakawa Tomiko

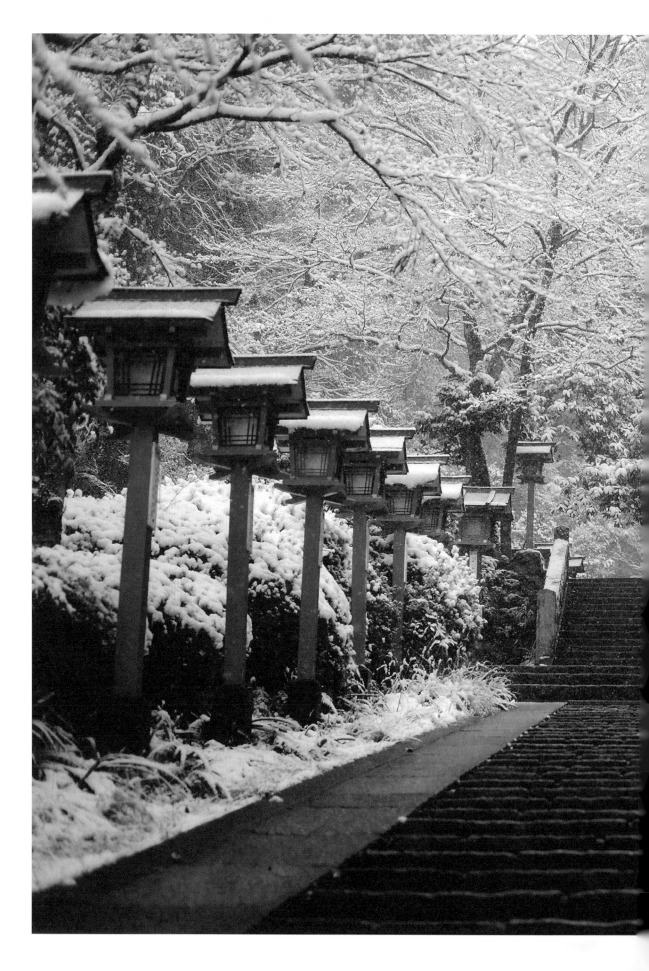

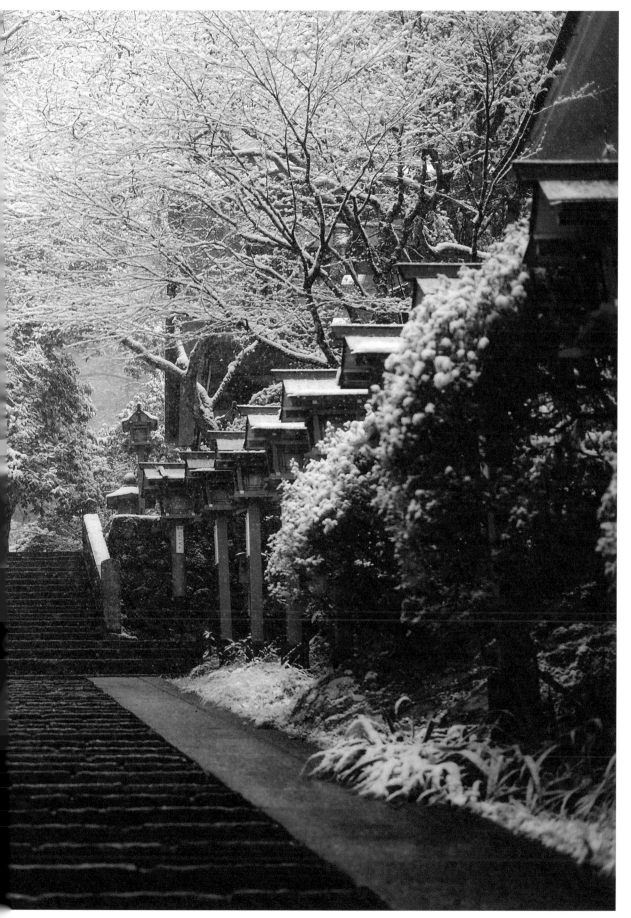

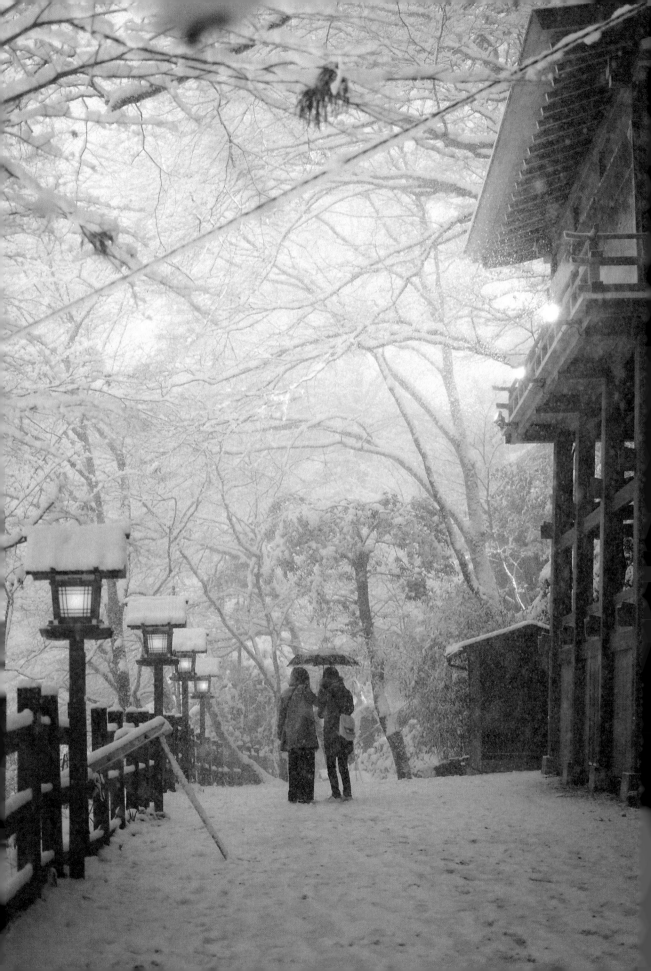

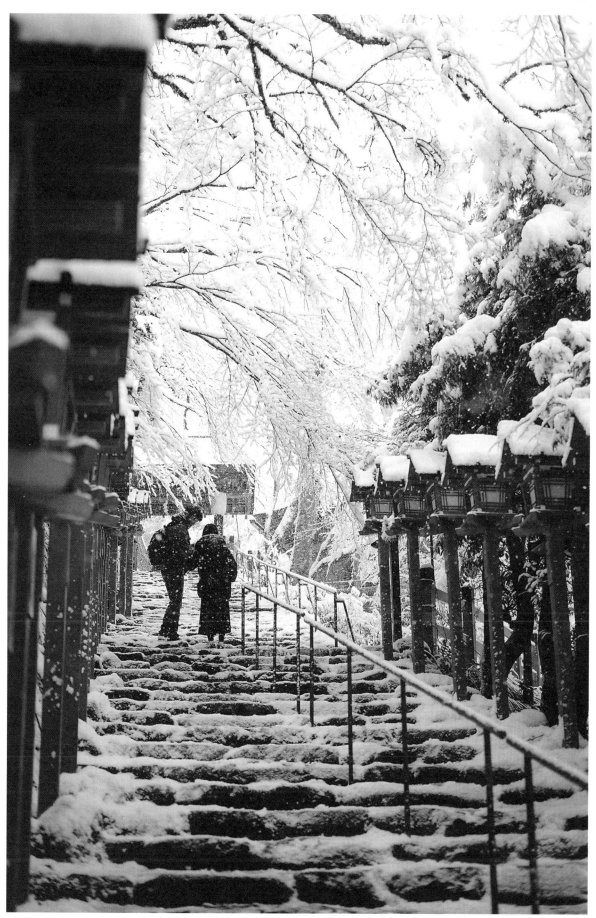

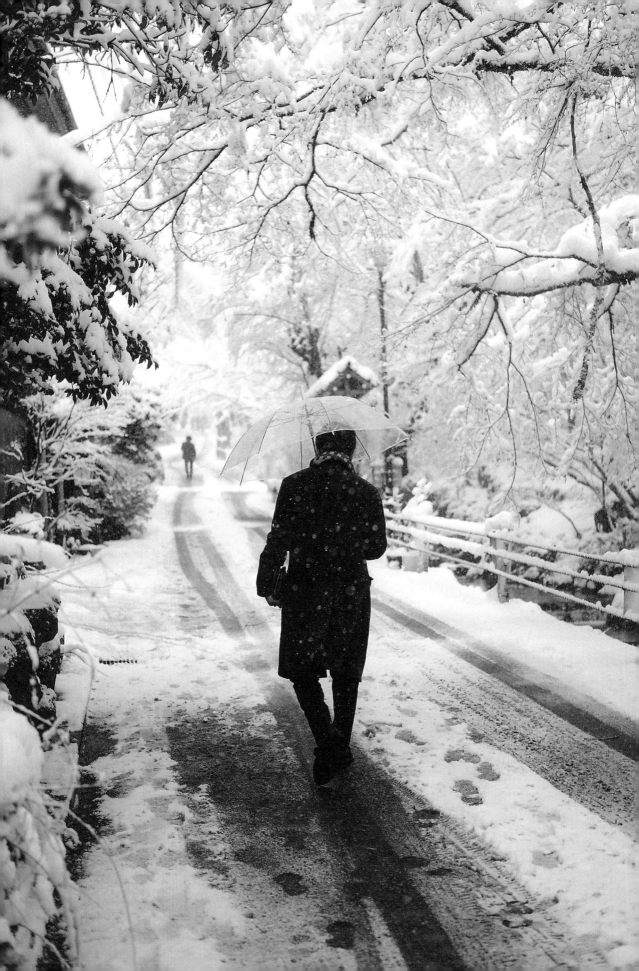

ひごろ
にくき鳥も
雪の朝哉

松尾
芭蕉

Most days they're hateful, yet

Even the crows, against the snow

This morning seem fine.

Bashō

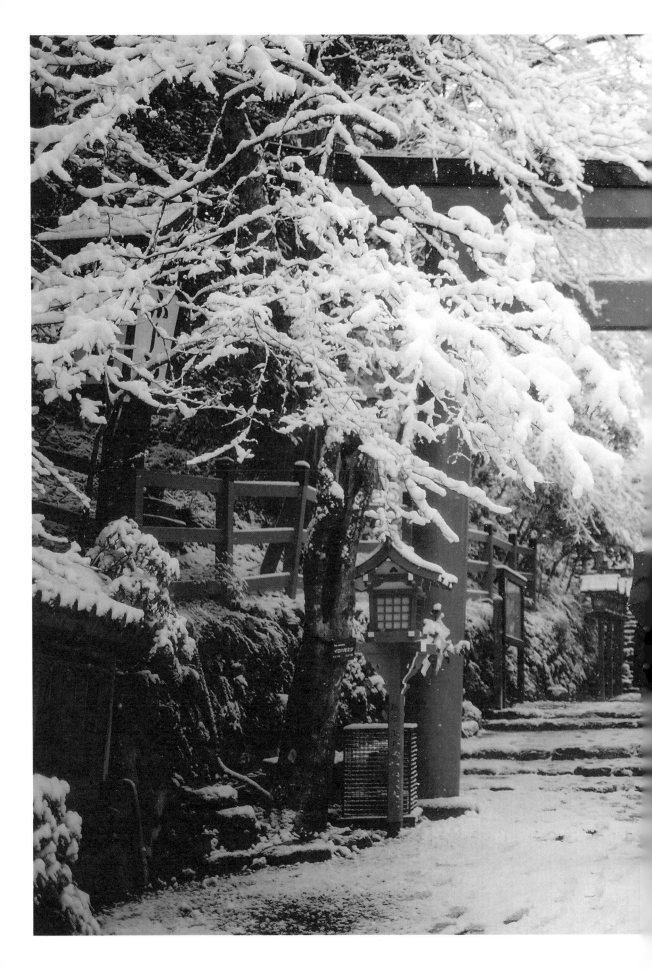

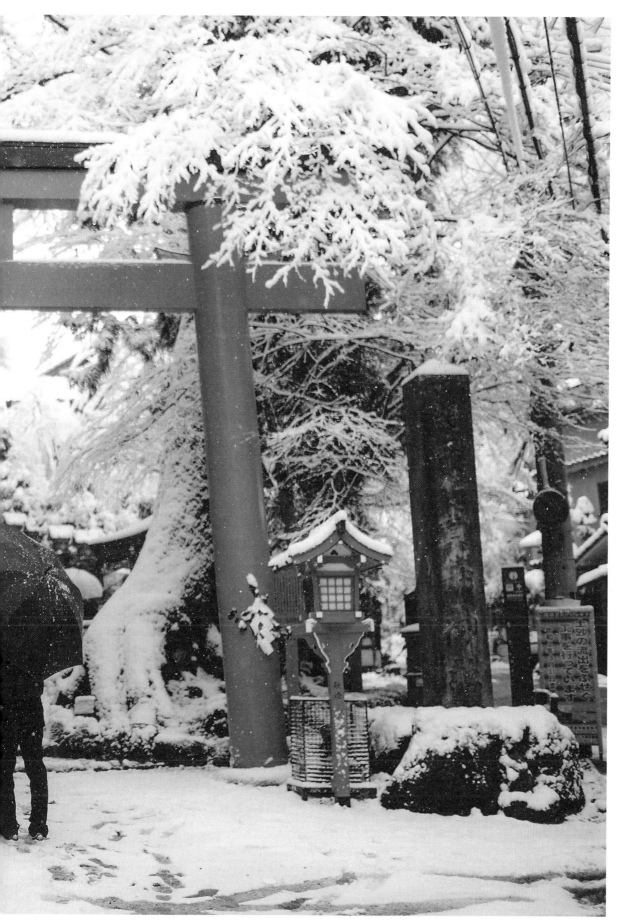

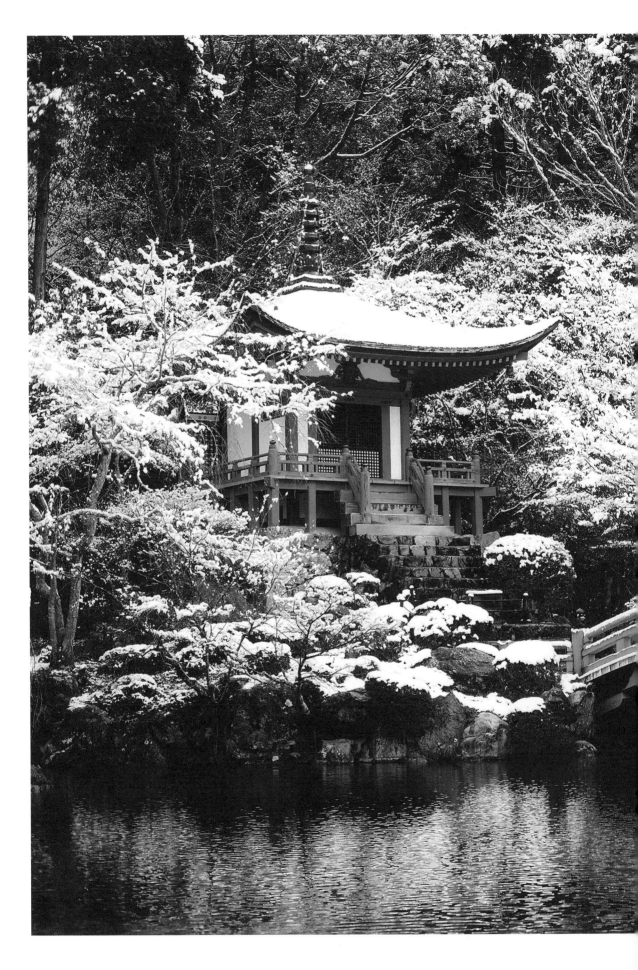

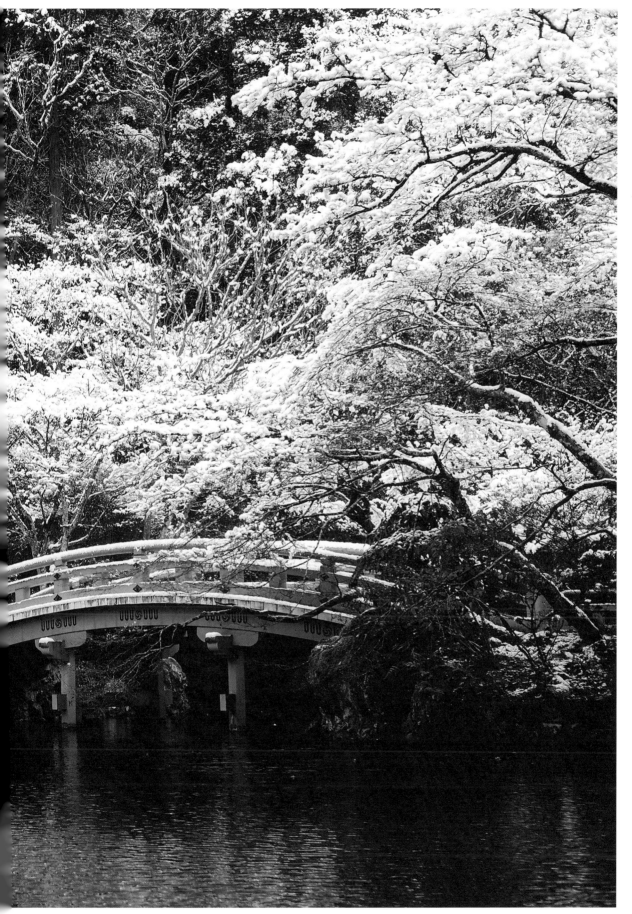

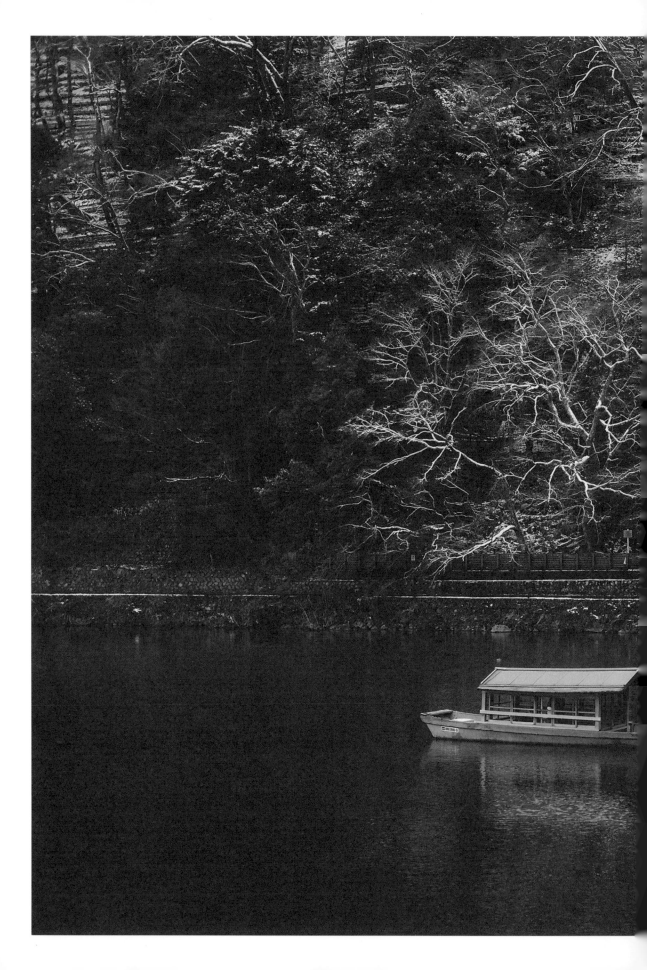

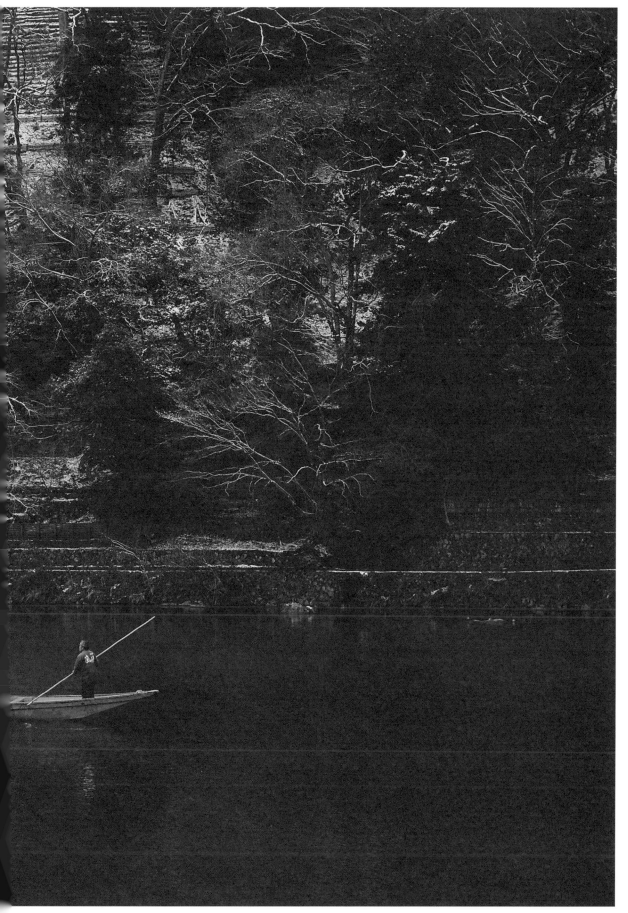

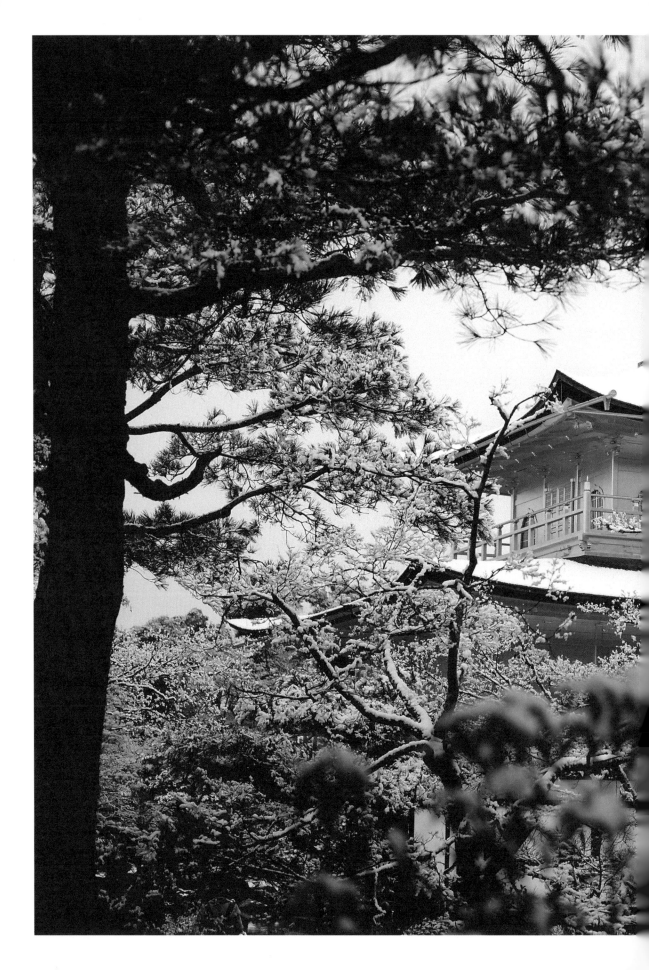

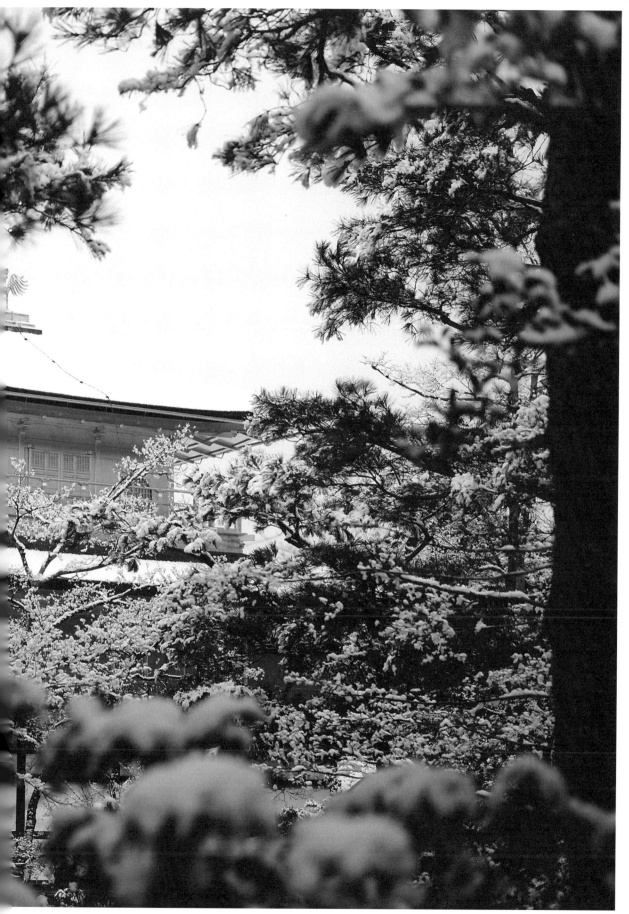

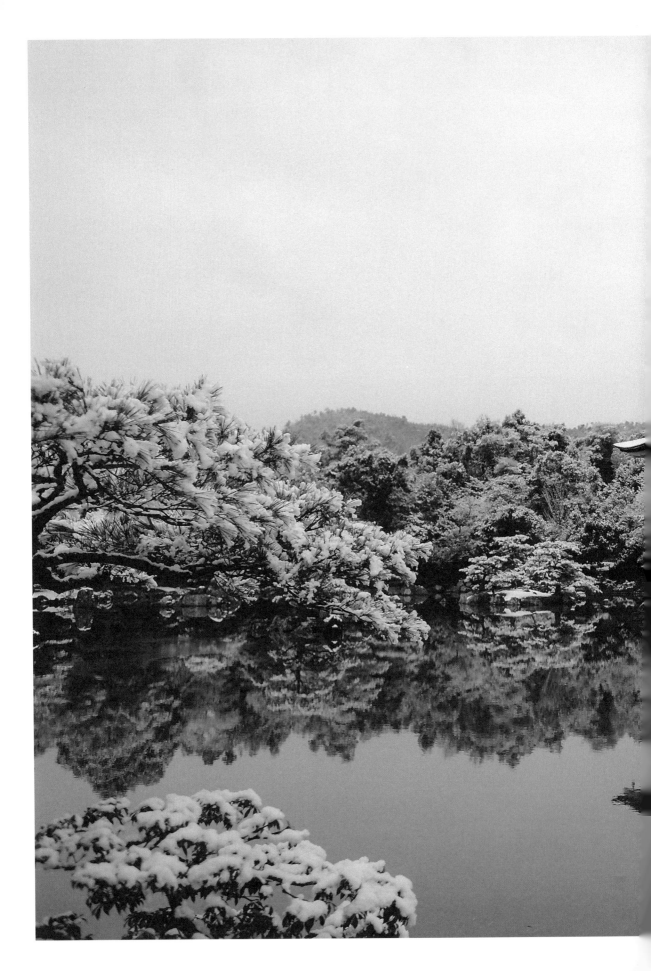

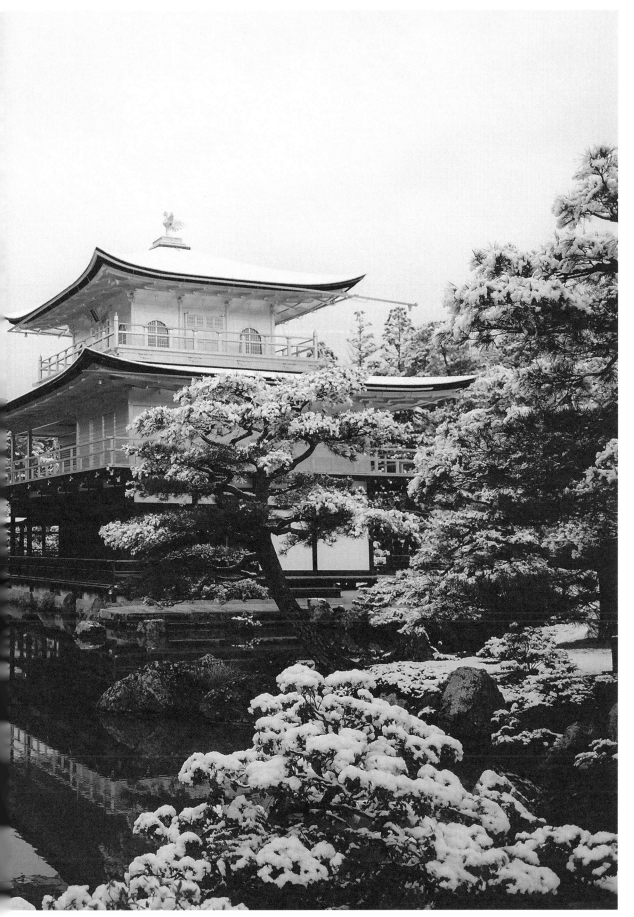

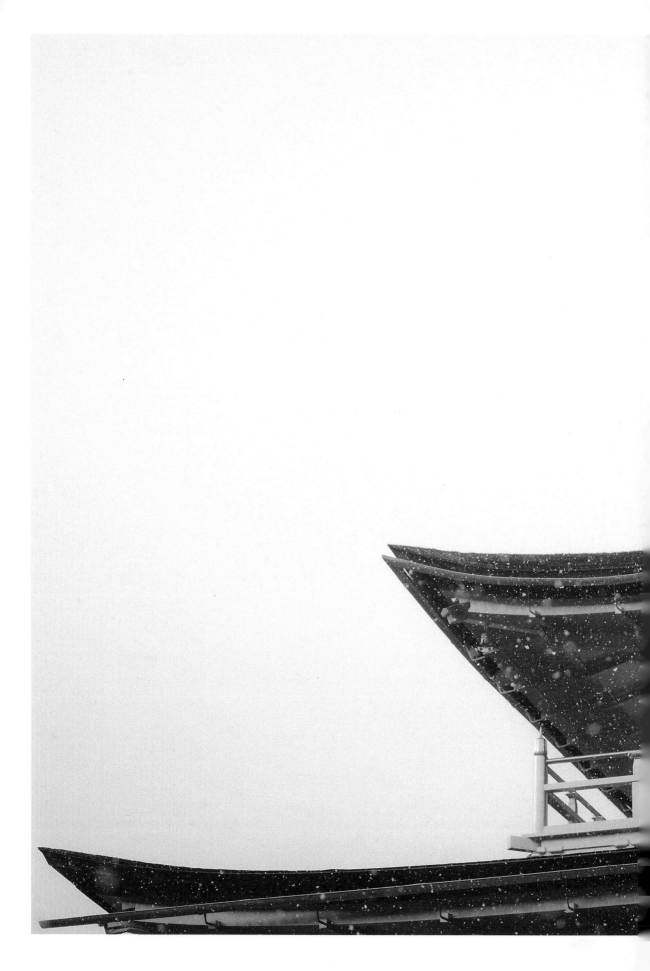

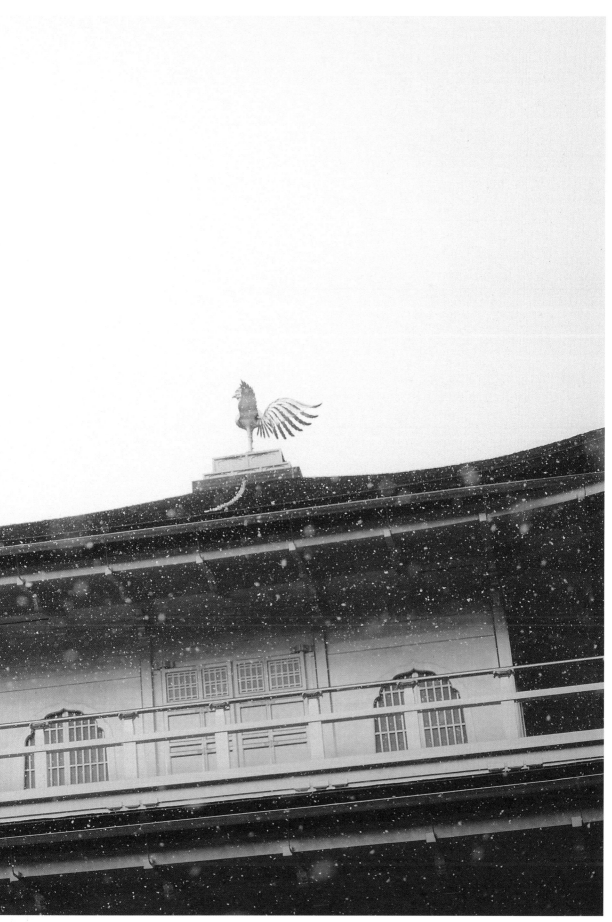

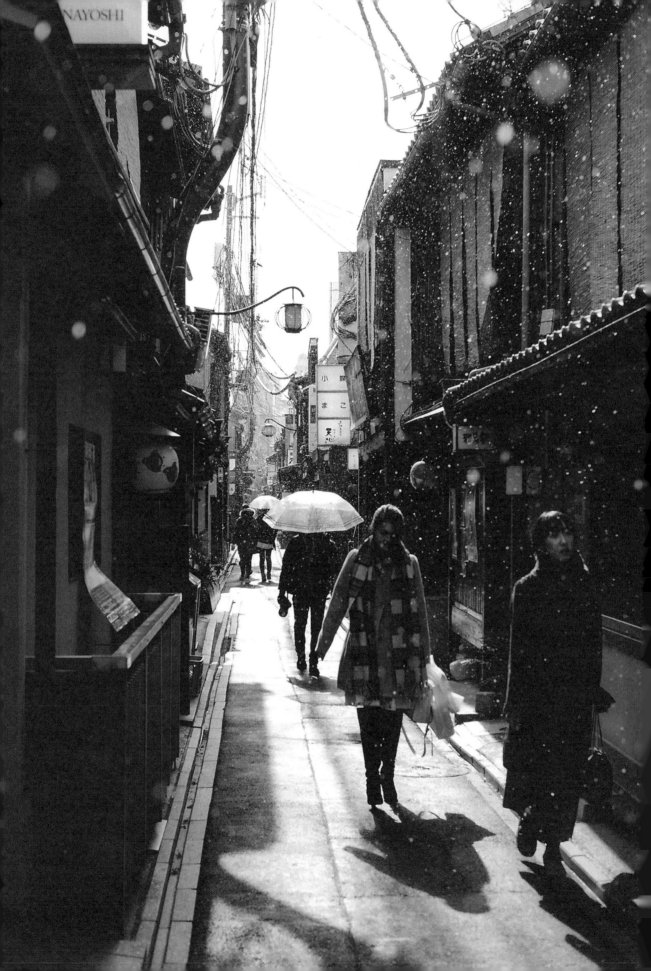

下京や
雪つむ上の
夜の雨

野沢凡兆

Lower Kyoto —

on a blanket of snow

falls the evening rain

Bonchō

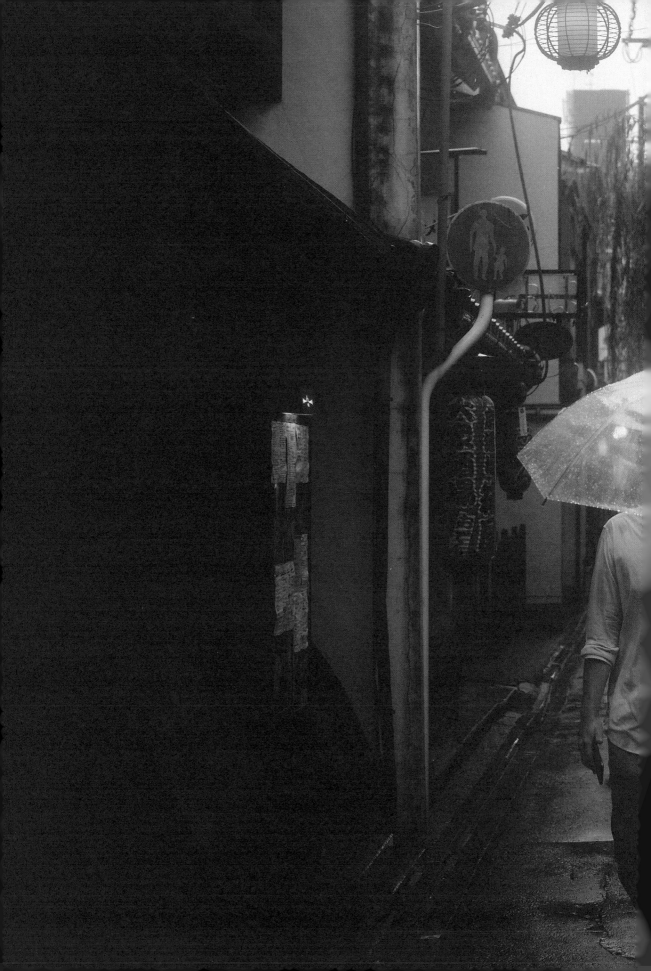

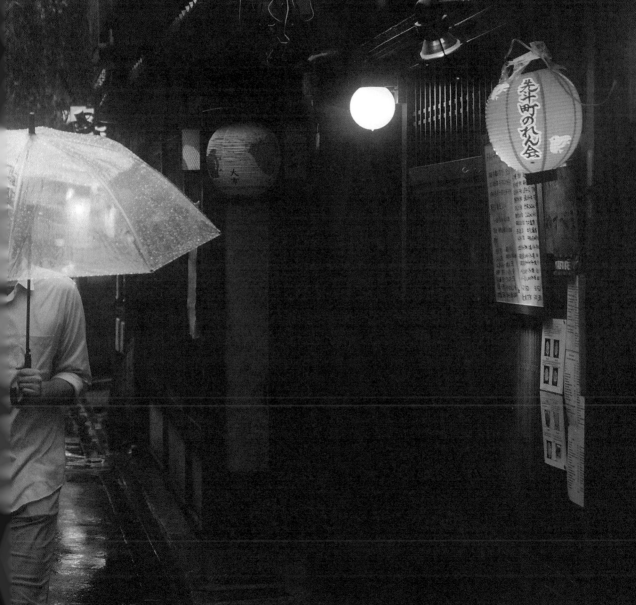

雨

RAIN

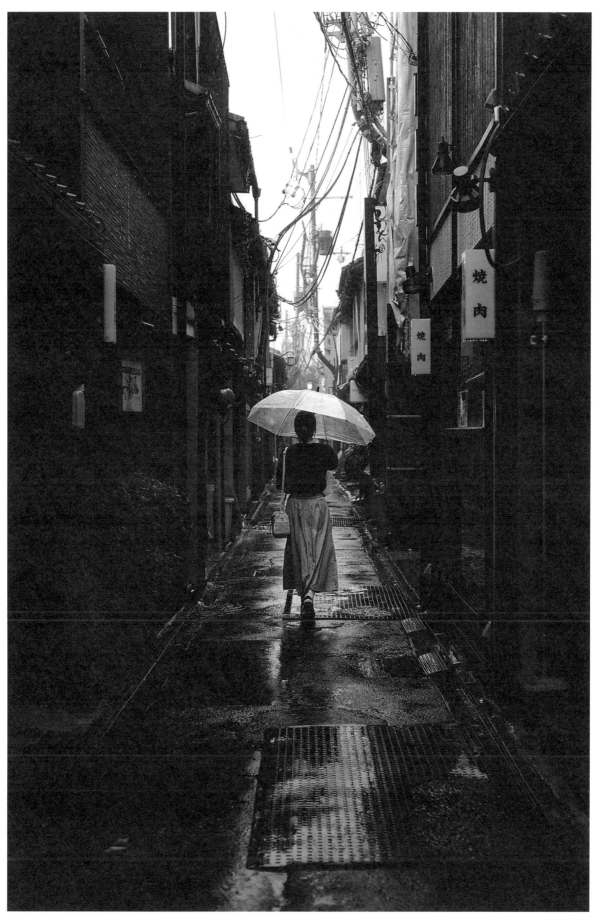

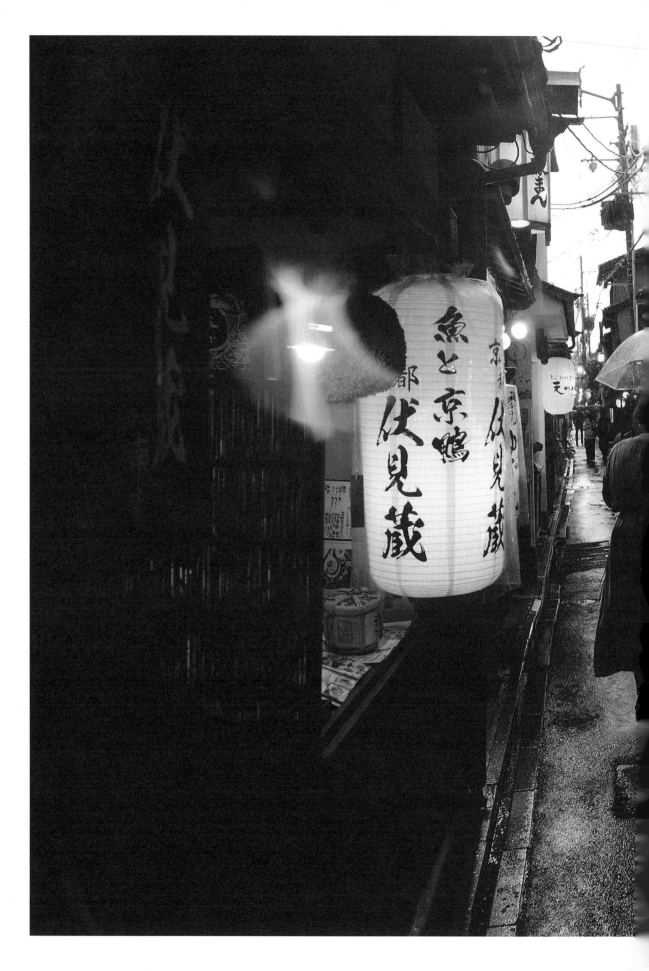

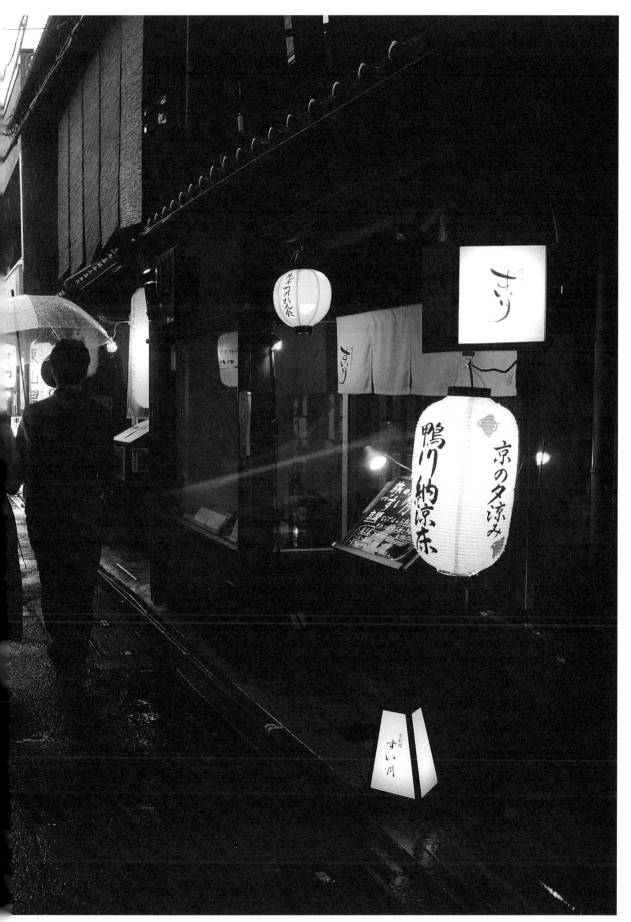

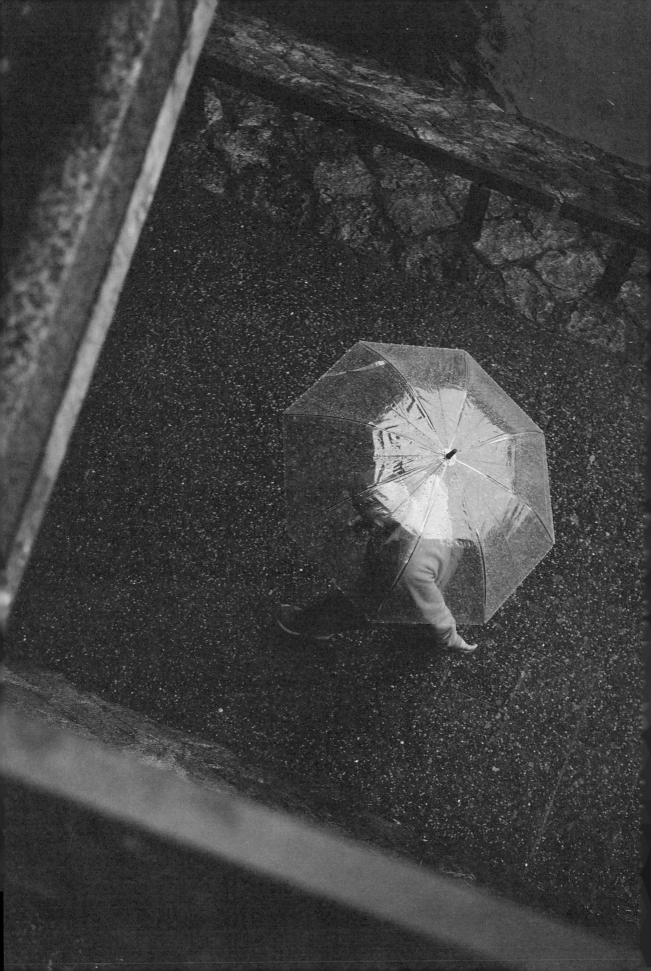

傘の雫も
かすむ
都哉

小林一茶

Paper umbrellas

dripping . . .

misty Kyoto

Kobayashi Issa

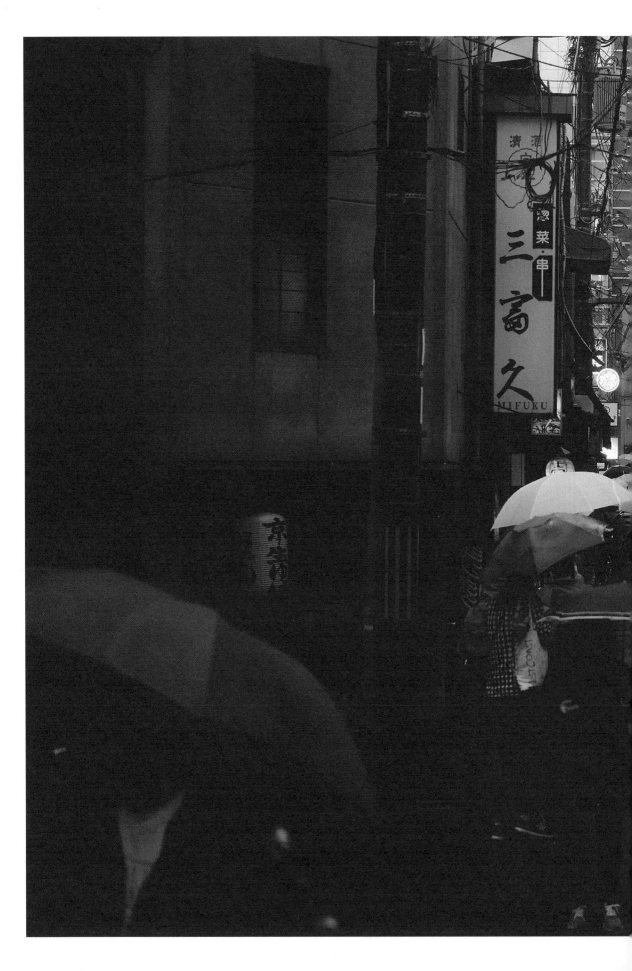

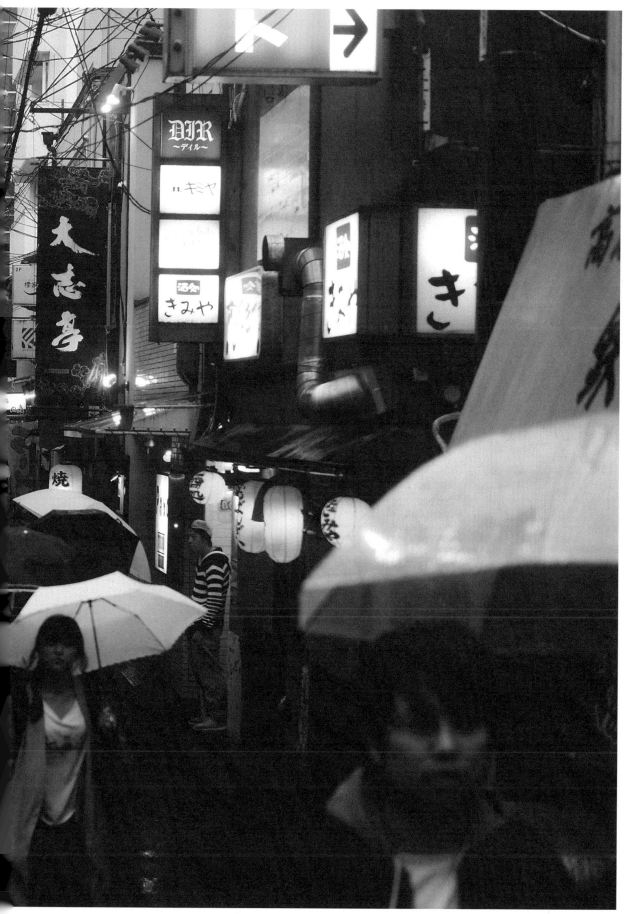

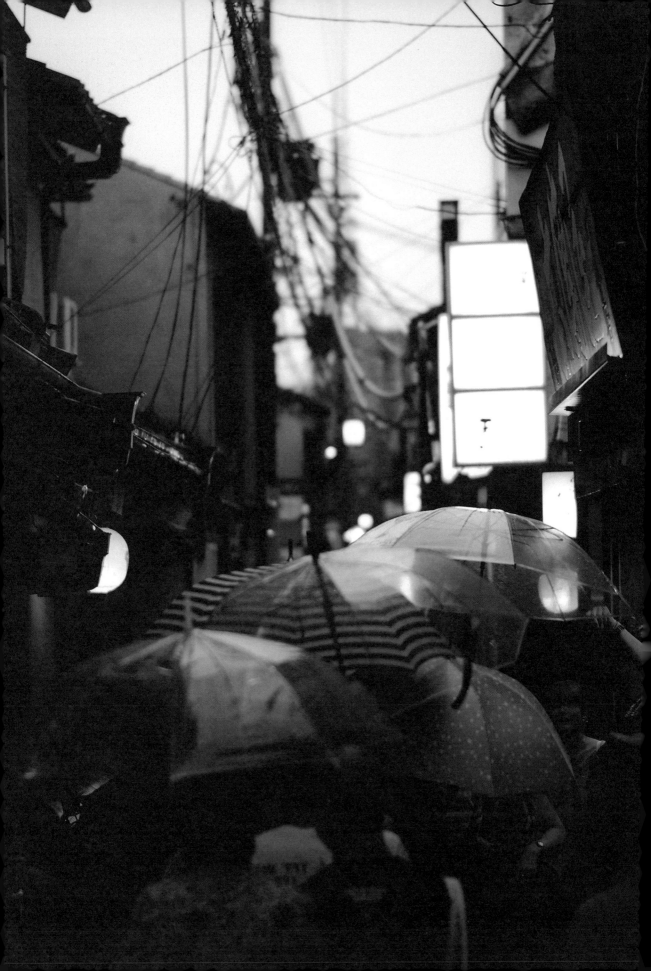

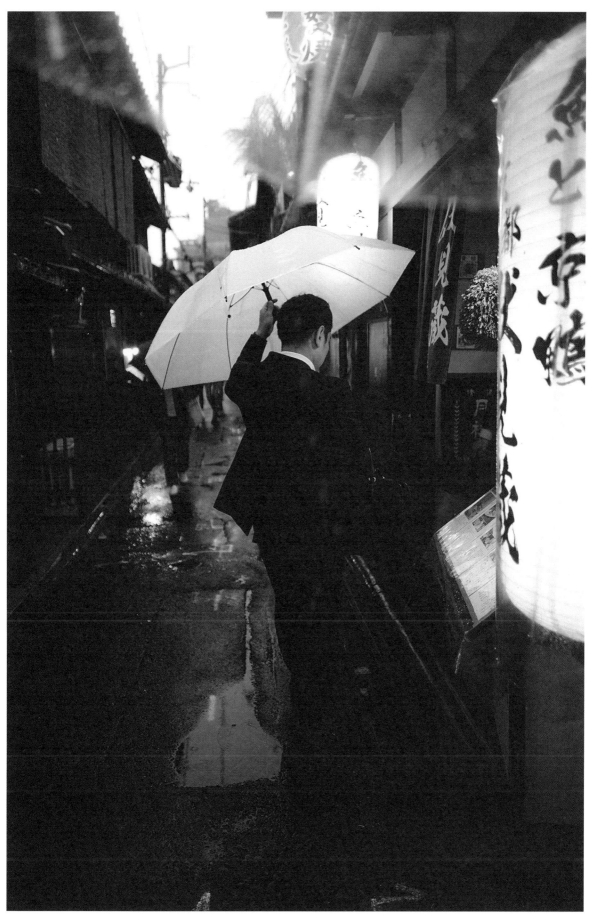

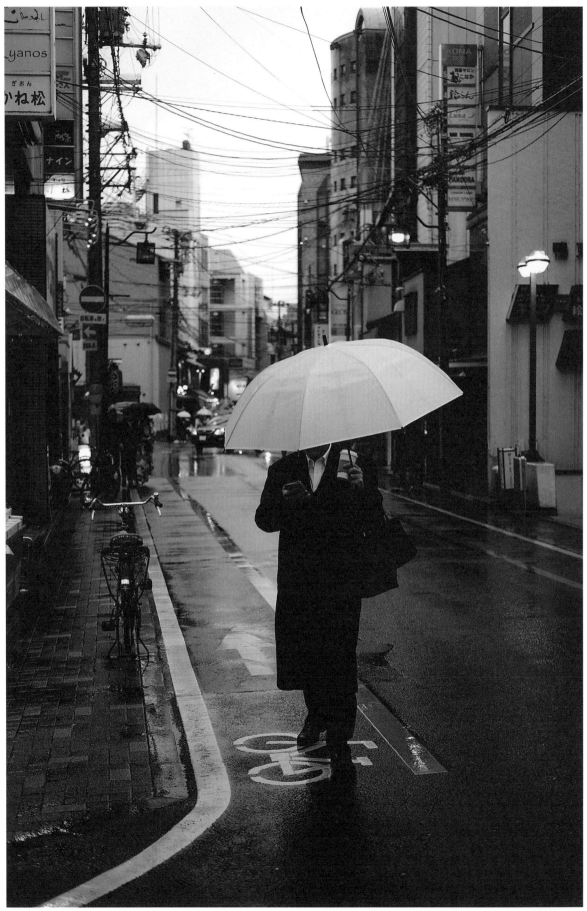

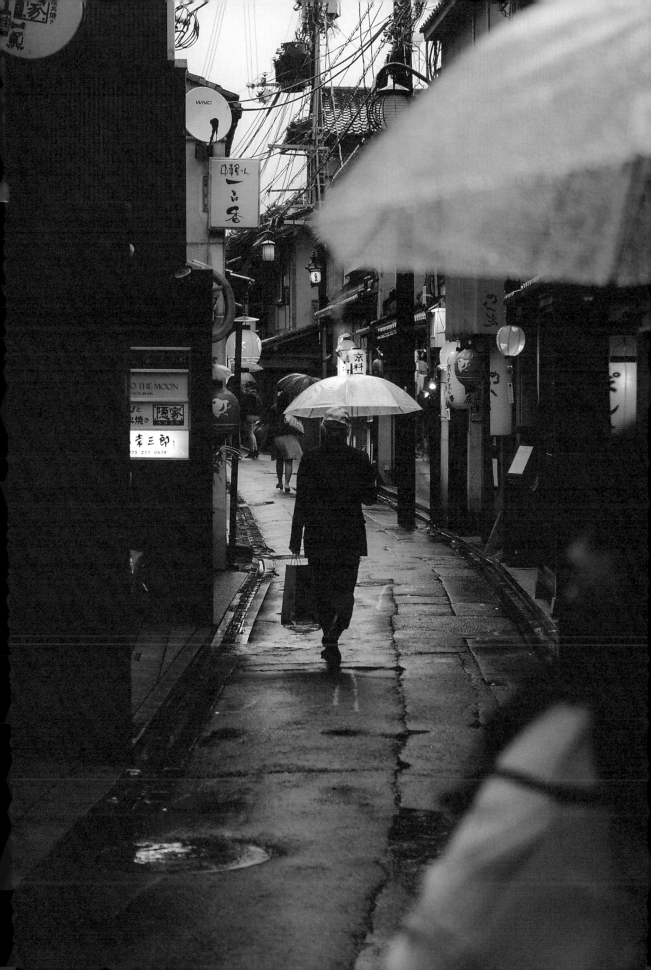

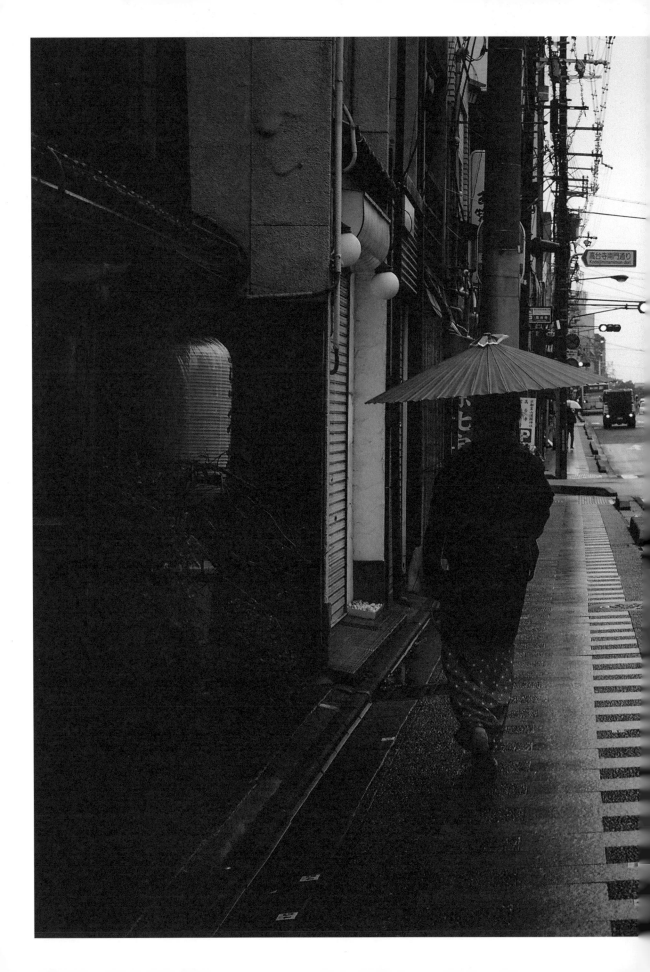

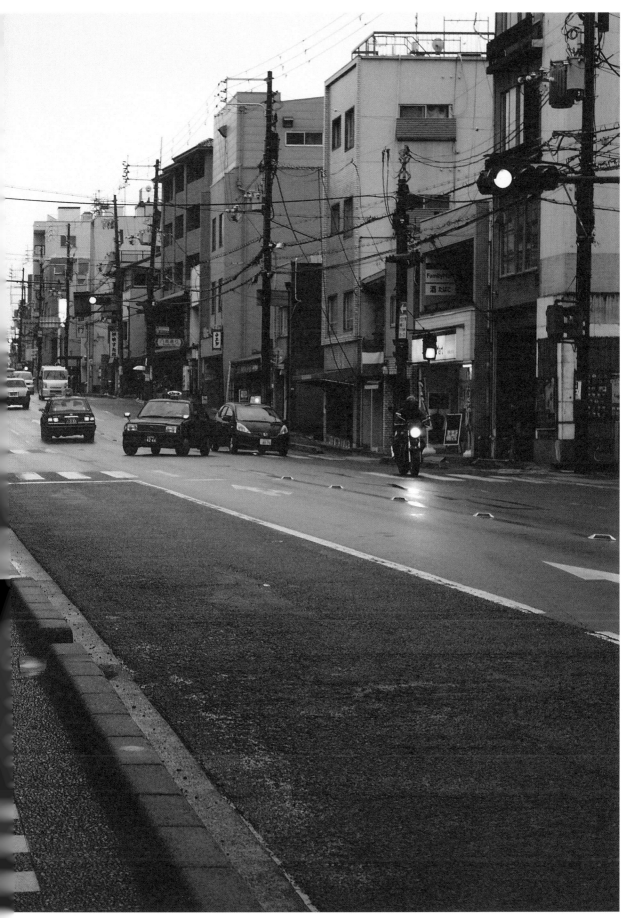

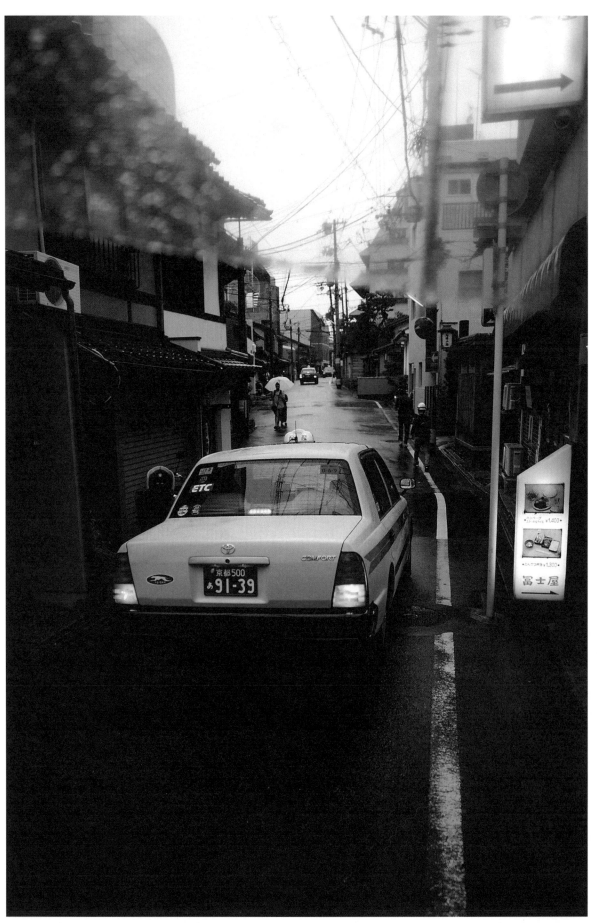

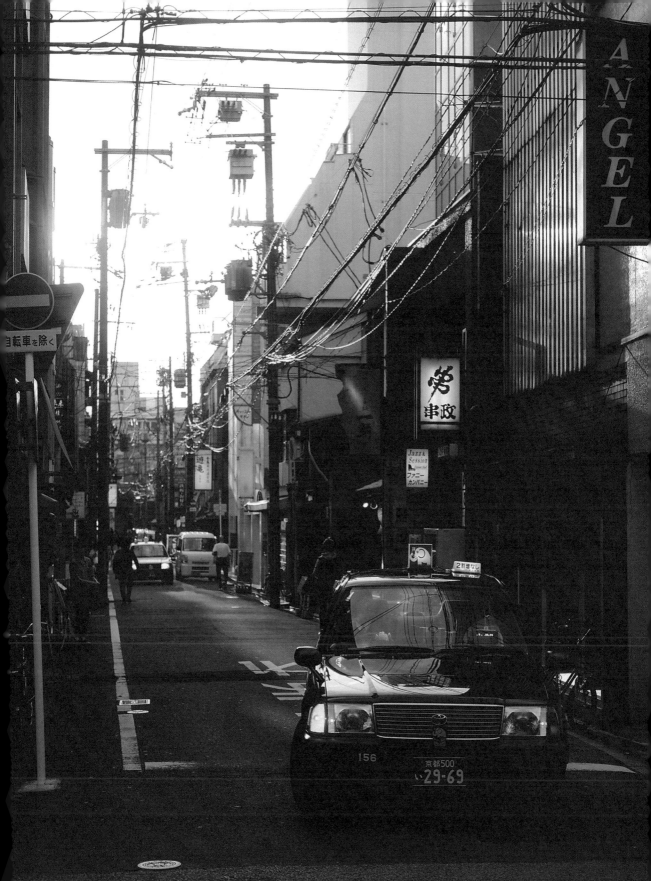

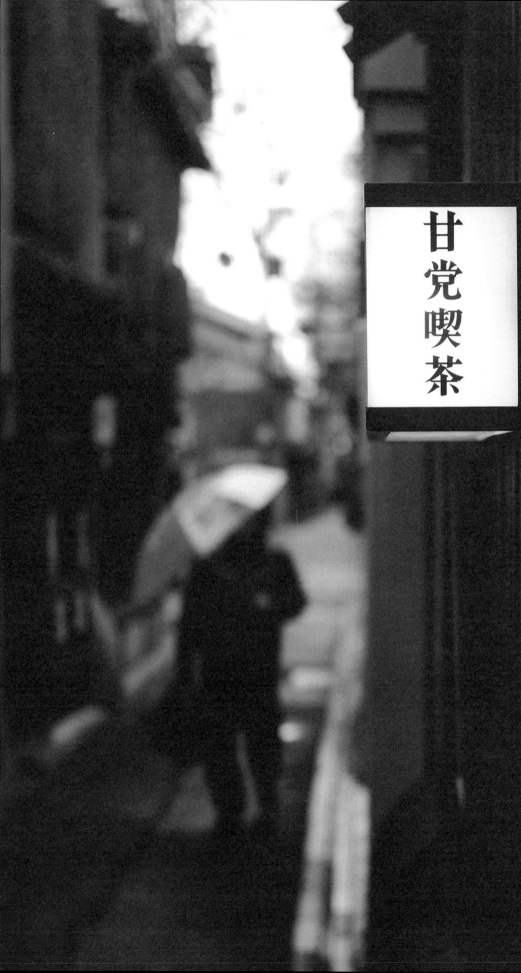

古傘の
婆さと月夜の
時雨哉

与謝蕪村

Old umbrellas

Spring up by the score on a moonlit night

When the rain comes down.

Yosa Buson

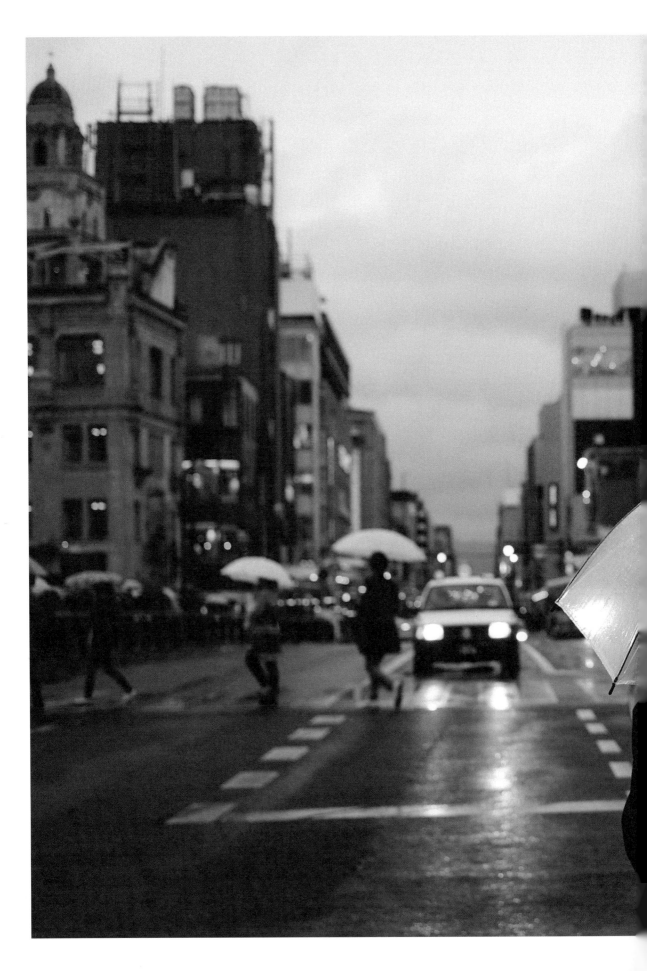

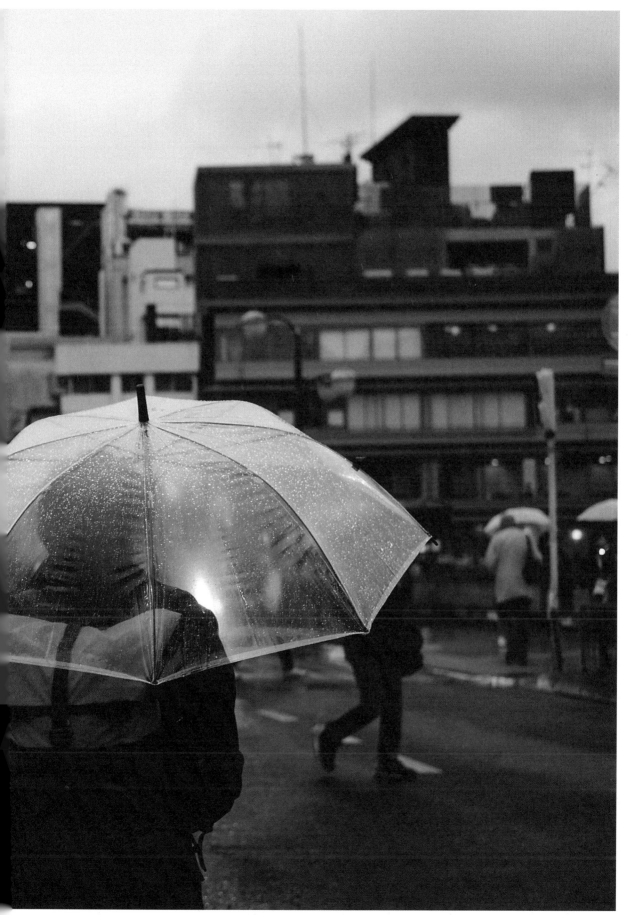

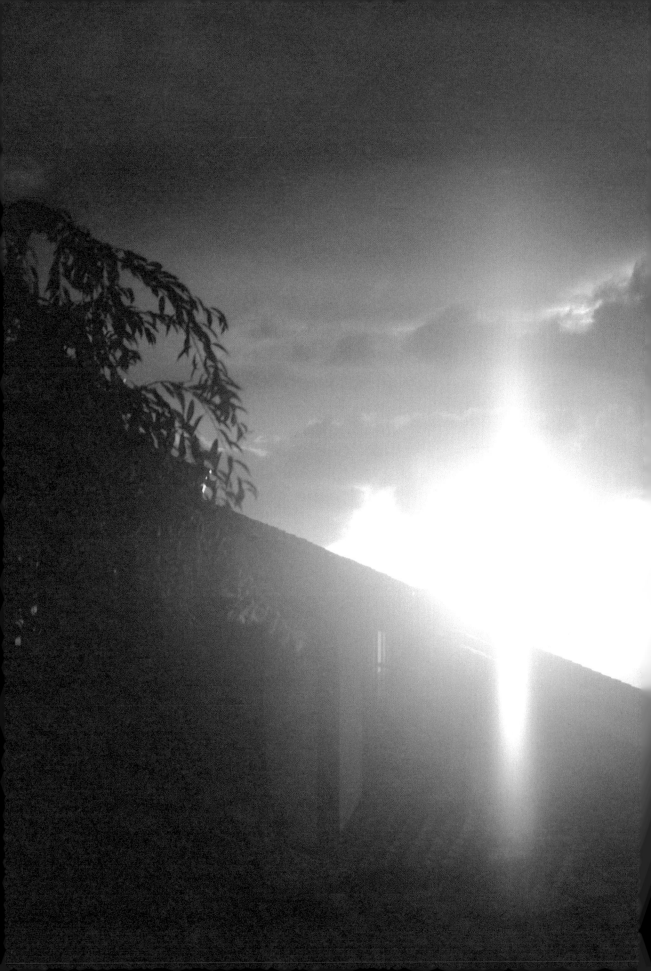

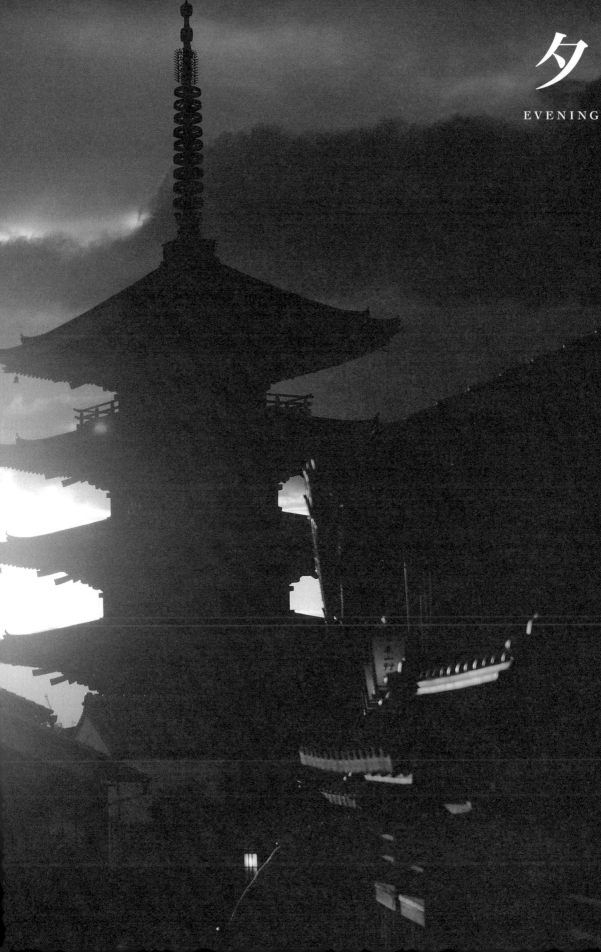

EVENING

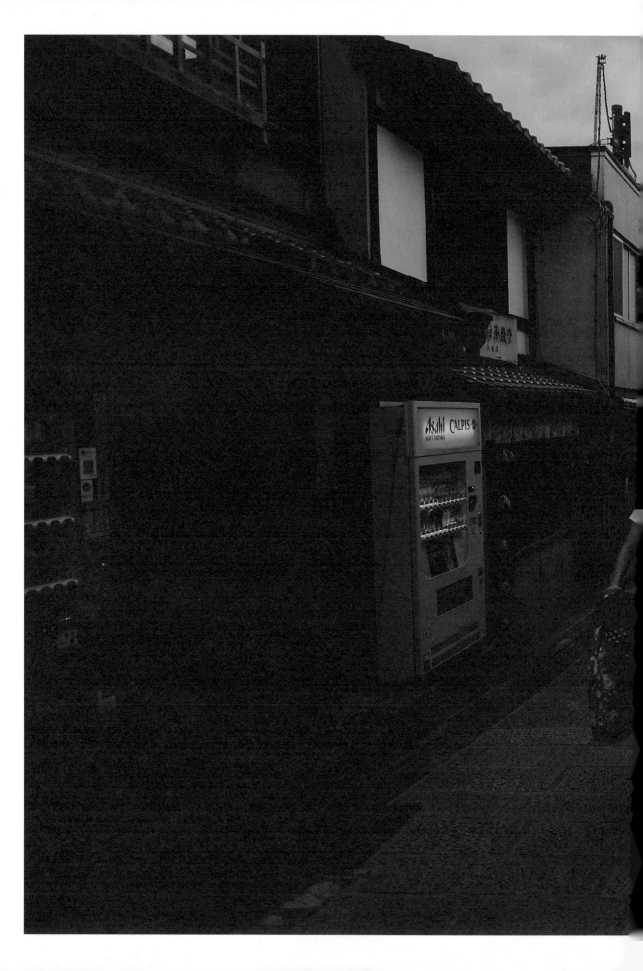

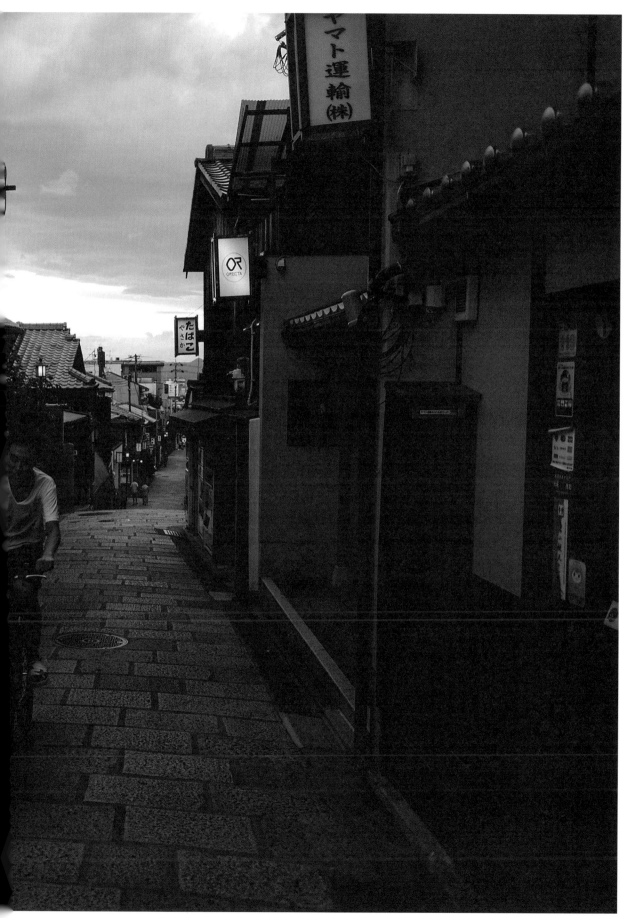

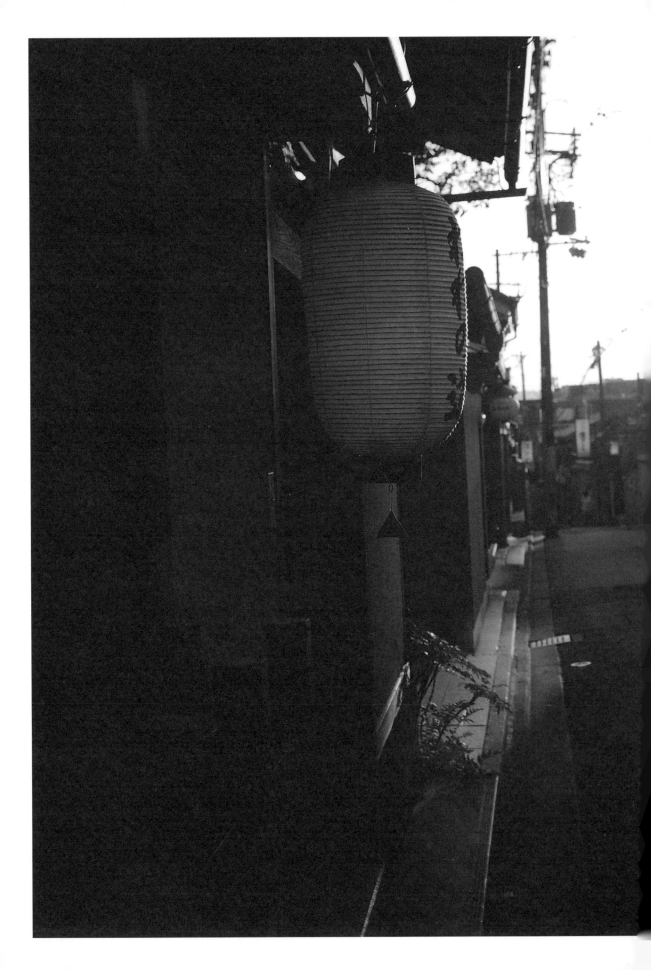

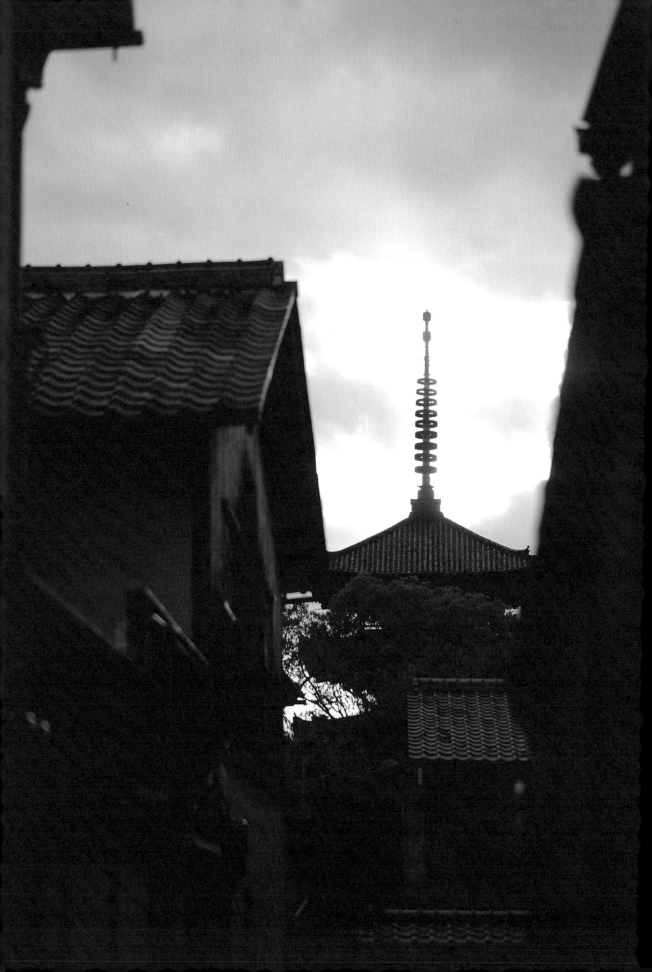

鐘消えて
花の香は撞く
夕べ哉

松尾芭蕉

Temple bells die out.

The fragrant blossoms remain.

A perfect evening!

Bashō

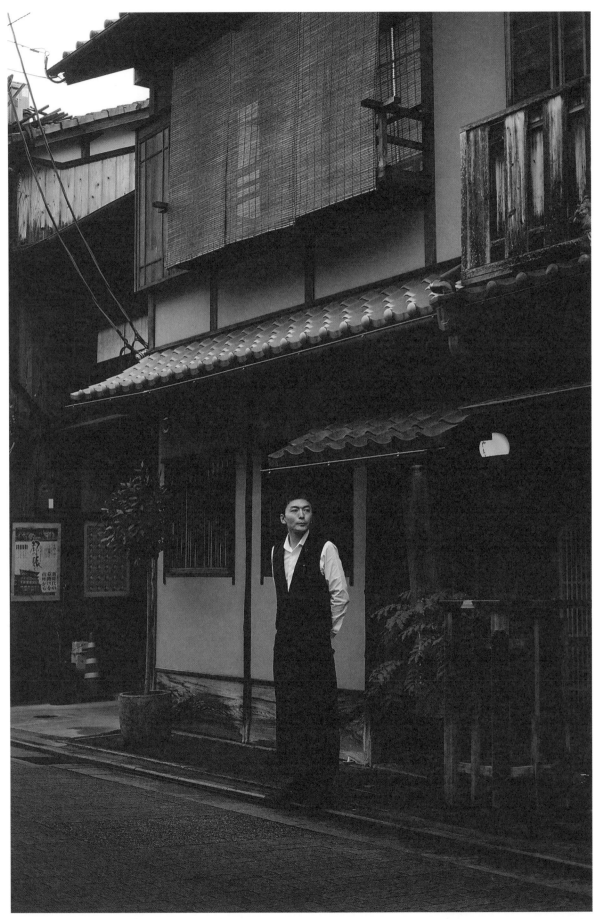

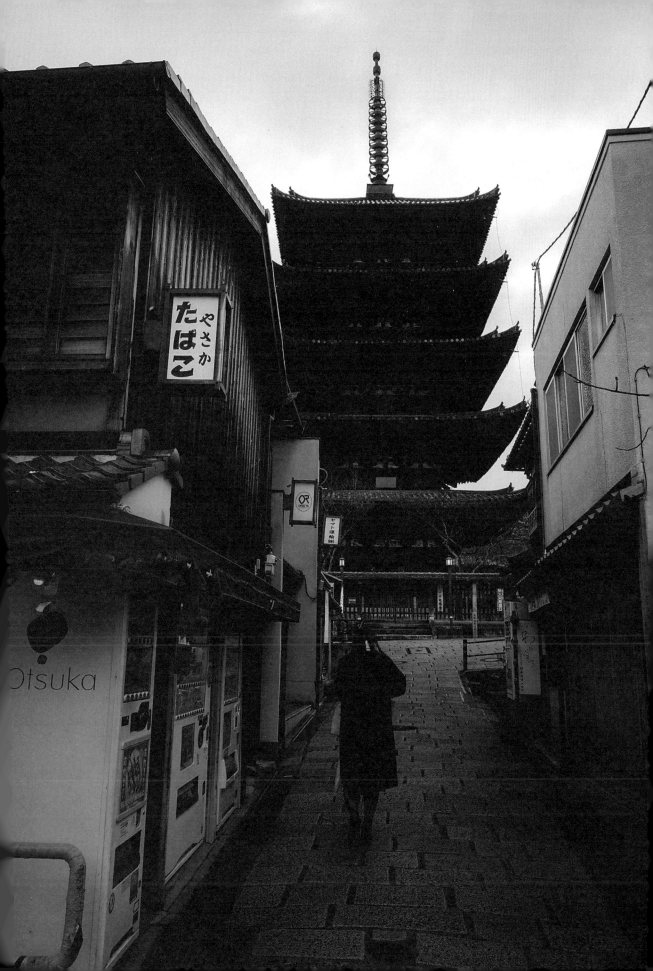

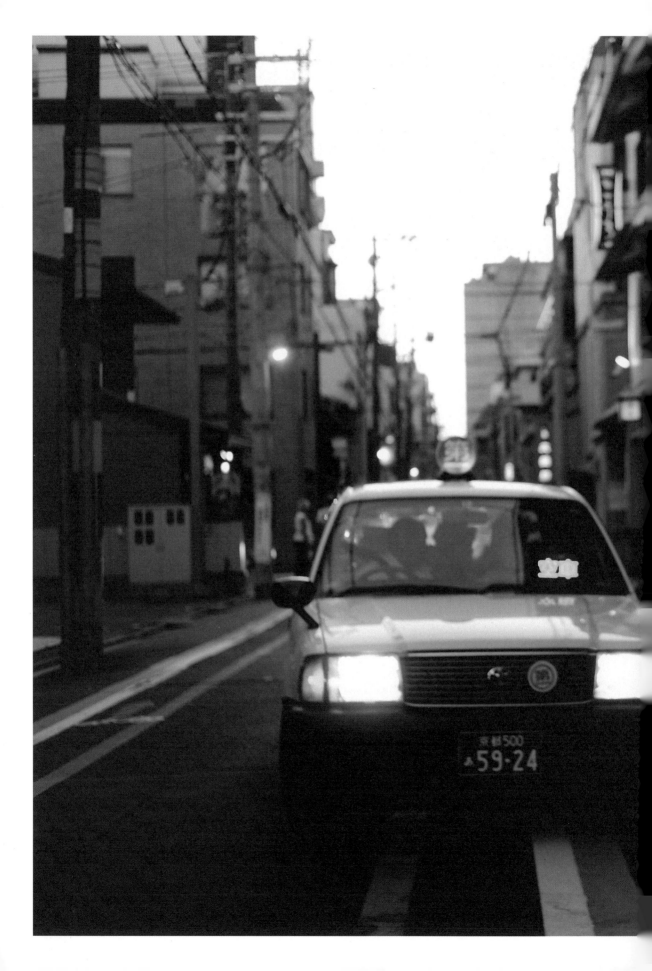

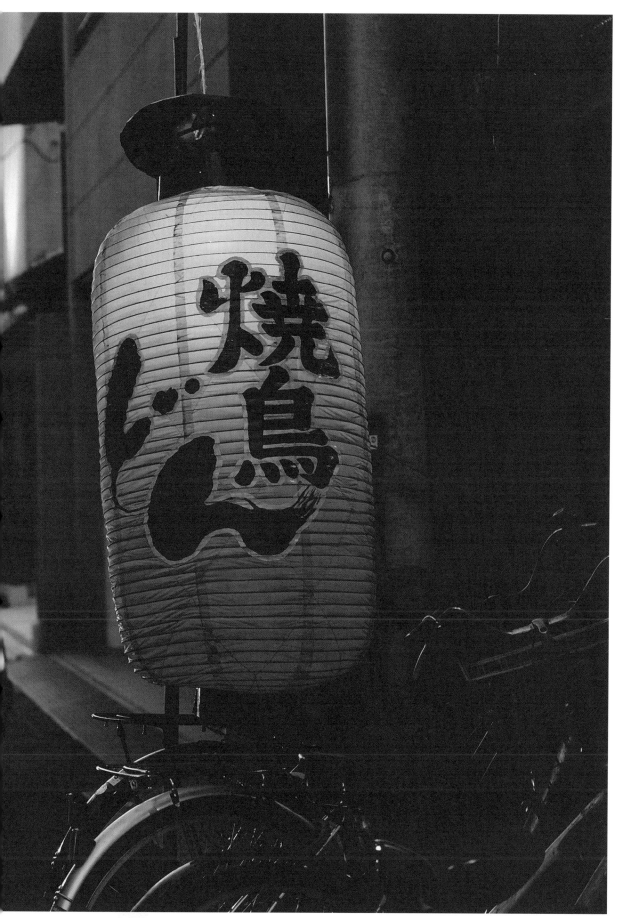

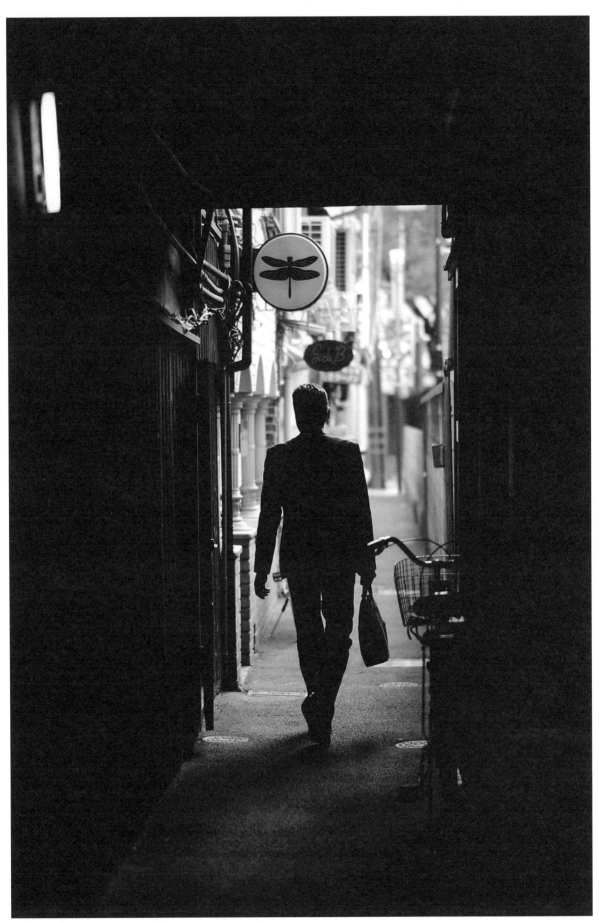

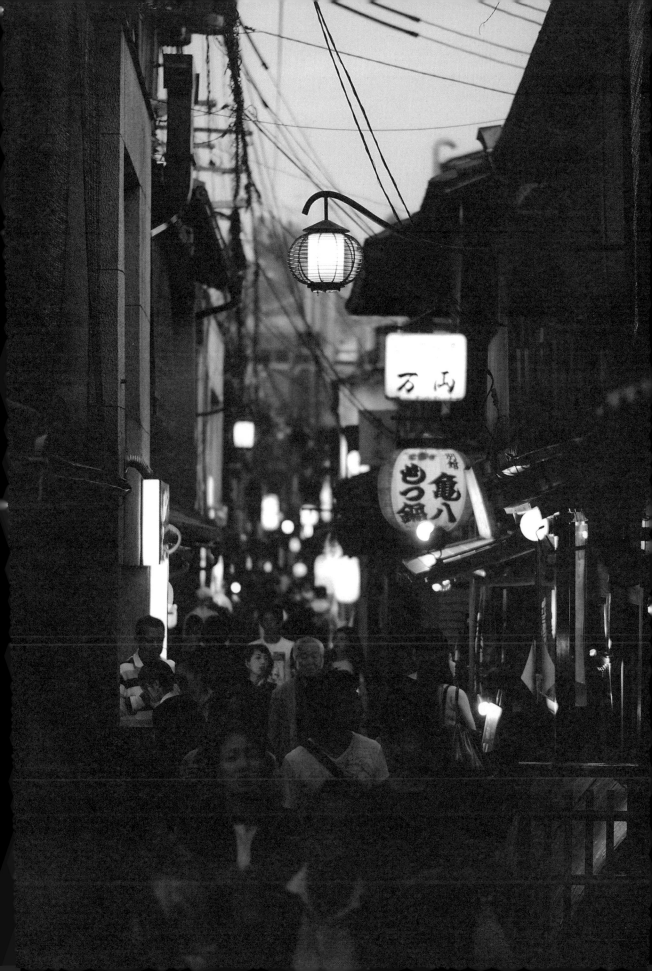

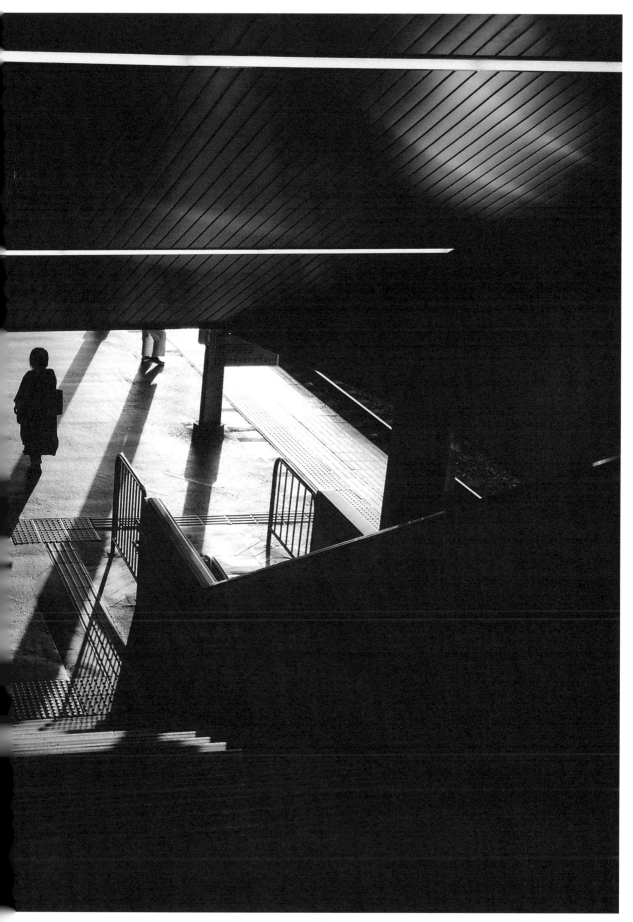

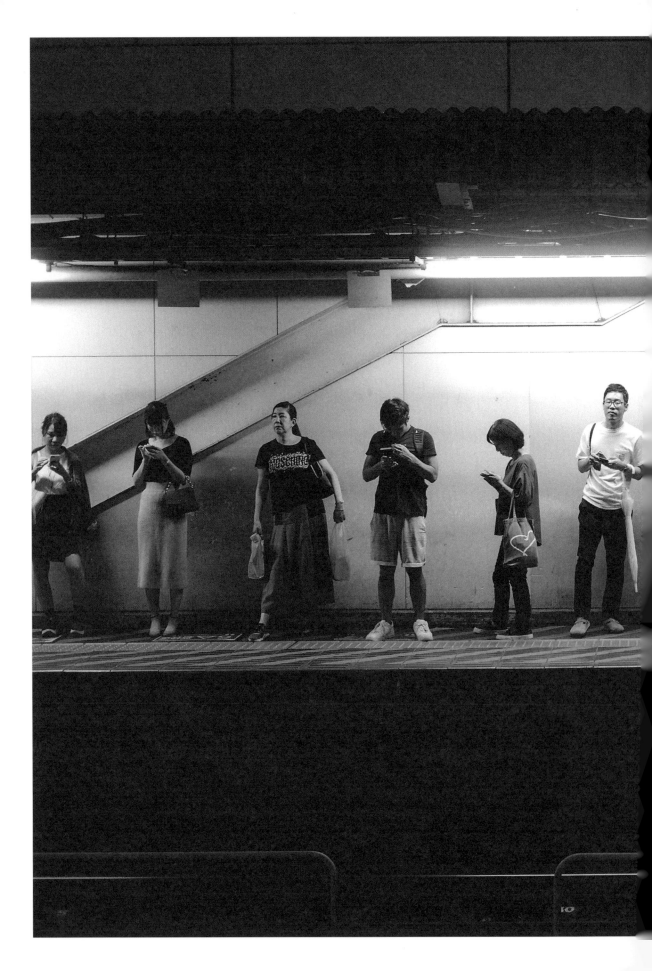

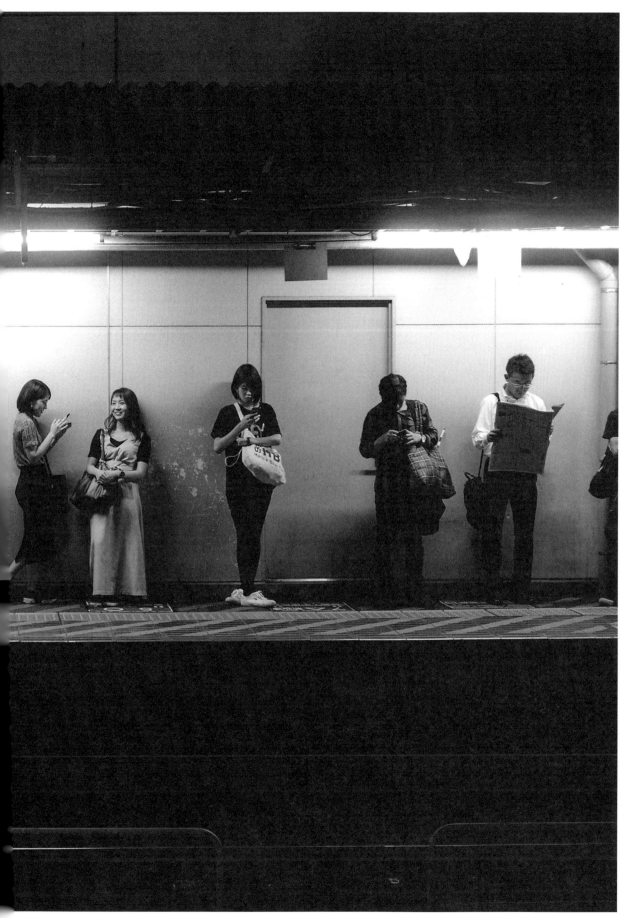

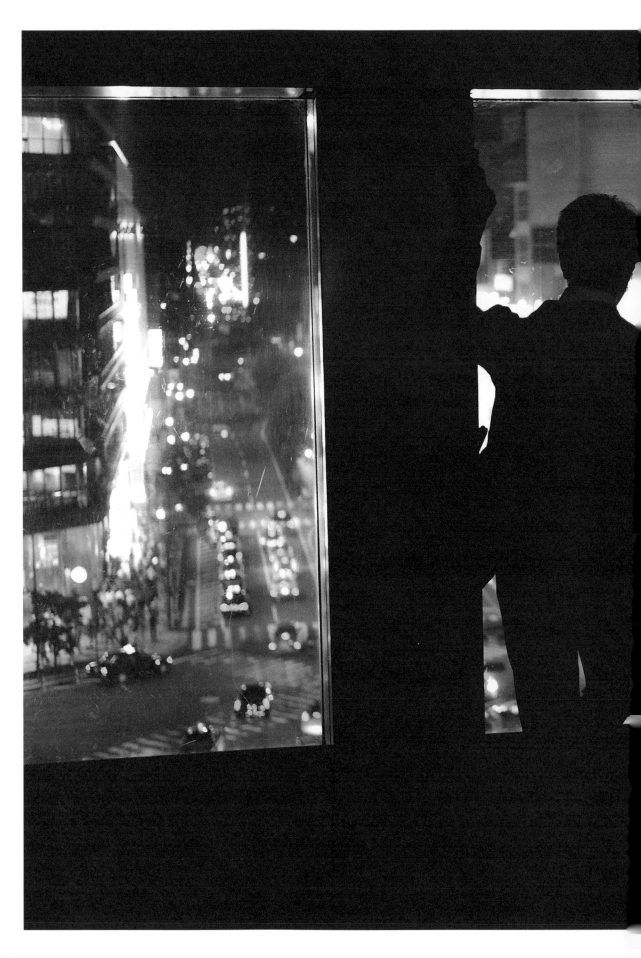

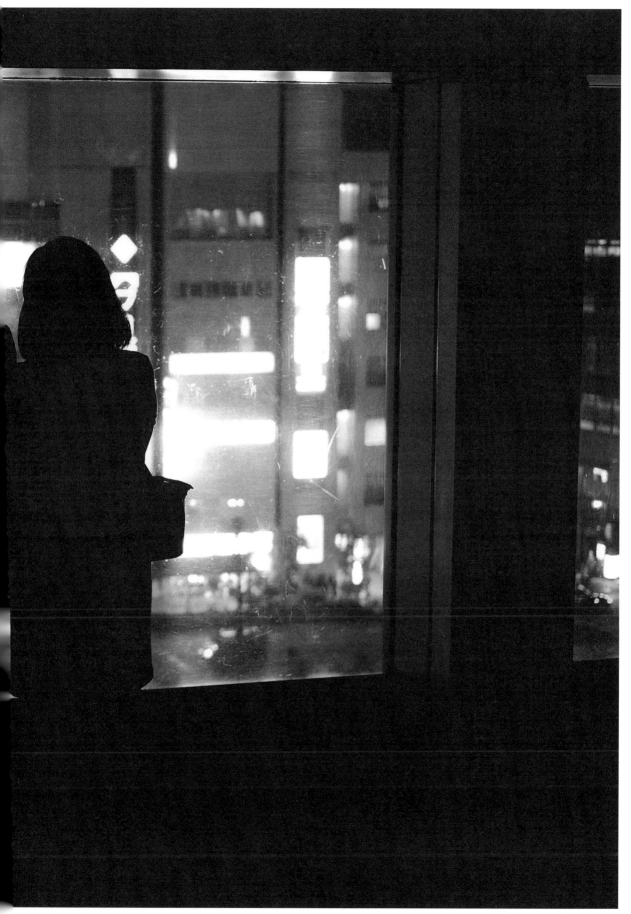

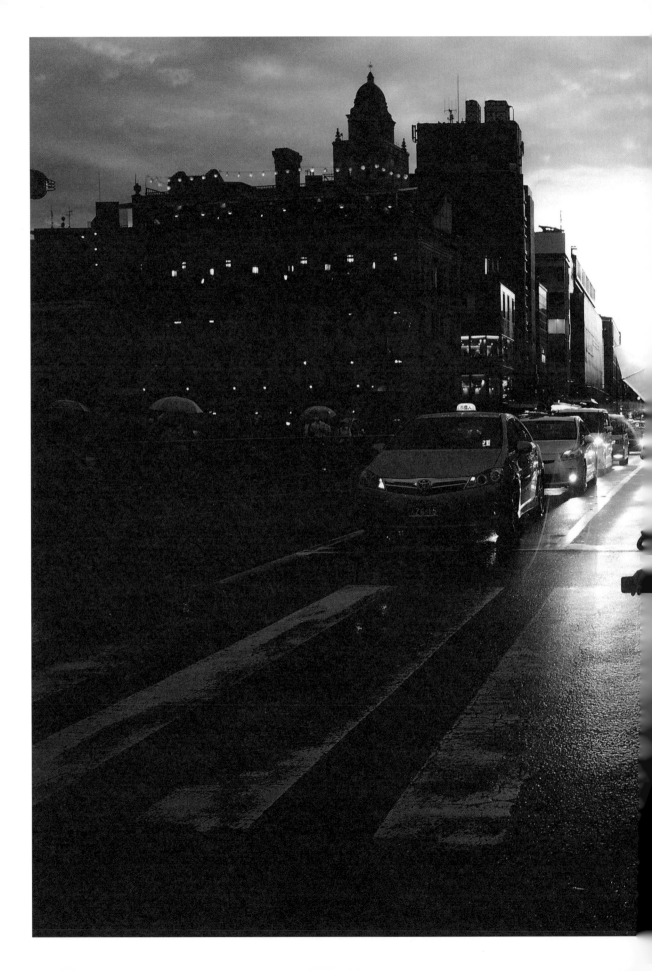

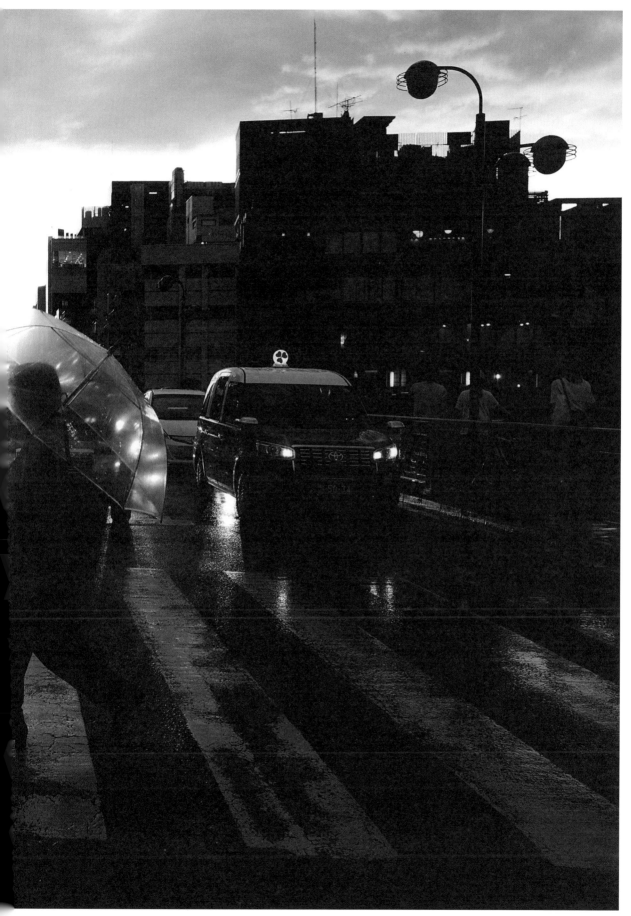

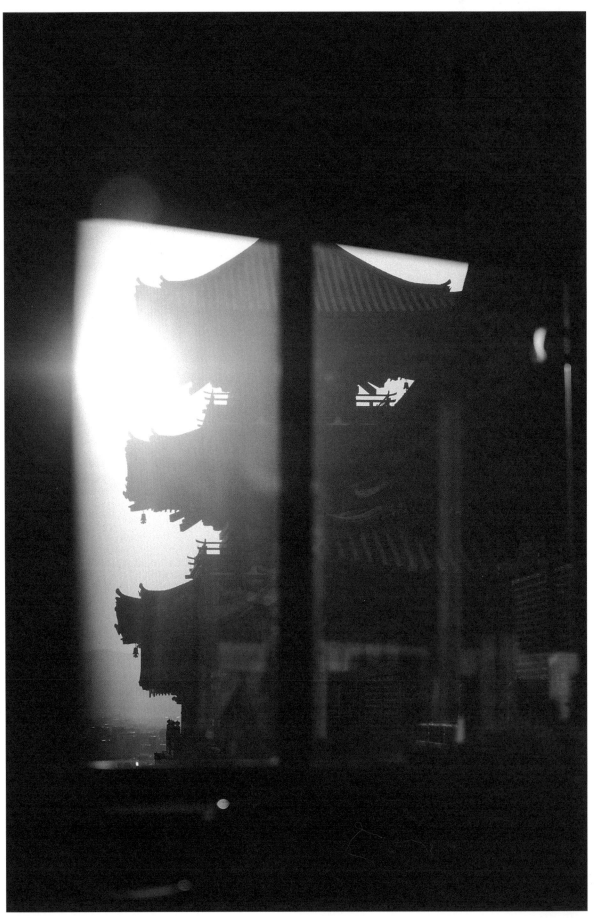

時鳥

鳴きつるかたを

ながむれば

たゞ有明の

月ぞのこれる

藤原実定

A cuckoo

Calls from yonder —

Gazing there,

Only the daybreak

Moon remains.

Fujiwara no Sanesada

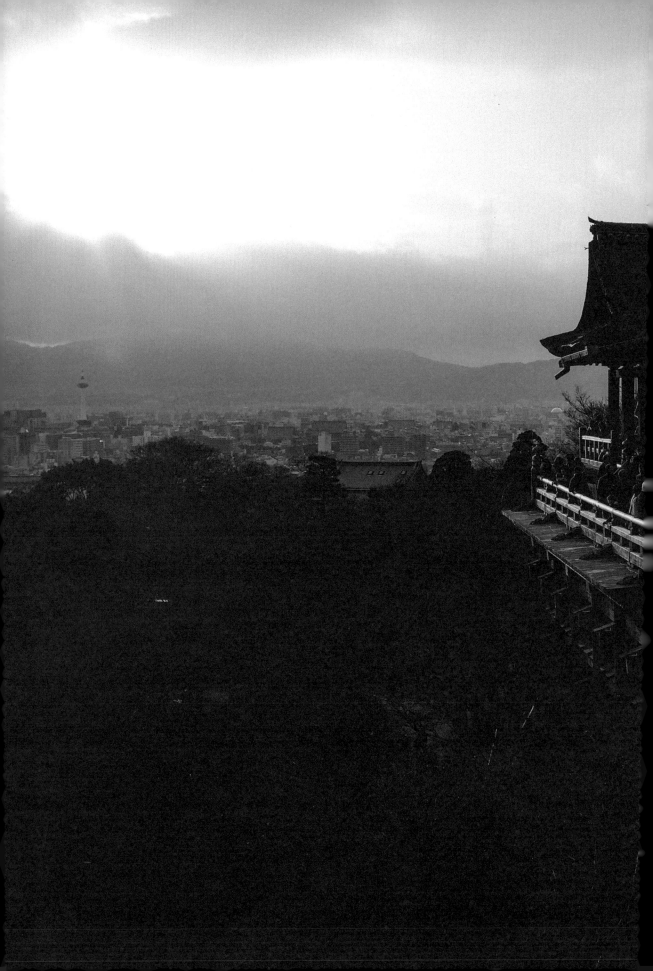

京に

IN KYOTO

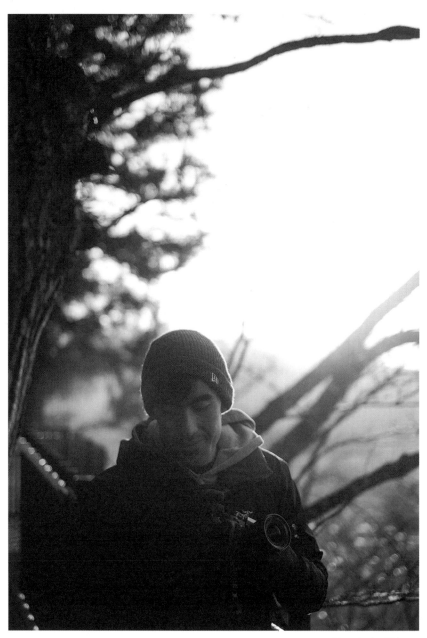

Photo by Jay Malano

TARO MOBERLY

———

Photography was always something I had interest in, going back to my childhood in the Bay Area of California. I remember being amazed by the photographs splashed across the pages of National Geographic magazine, and cautiously toying around with my father's old Leica SLR camera (and somehow not breaking it).

Photography developed into a passion when I moved to Kyoto, Japan, in 2015. At first, I only took photos to share my experiences in Japan with friends and family back home. Thanks to social media like Instagram, photography soon became a source of community as I met not only fellow photographers in Japan, but talented creatives from all corners of the globe, many of whom I am lucky to call good friends today. Connecting with such an incredible community motivated me to further develop my style as a photographer and explore more of the world around me, both within Japan and internationally. Photography became my key to learning more about the world and the cultures of the people that inhabit it.

I continue to use photography as a means to see the world. I strive to document and share cultures and environments not only in Japan, but in other countries as well. Through my images, I hope to inspire others to be more curious about the world around them, and to explore places and cultures that they otherwise might never have.

@taromoberly

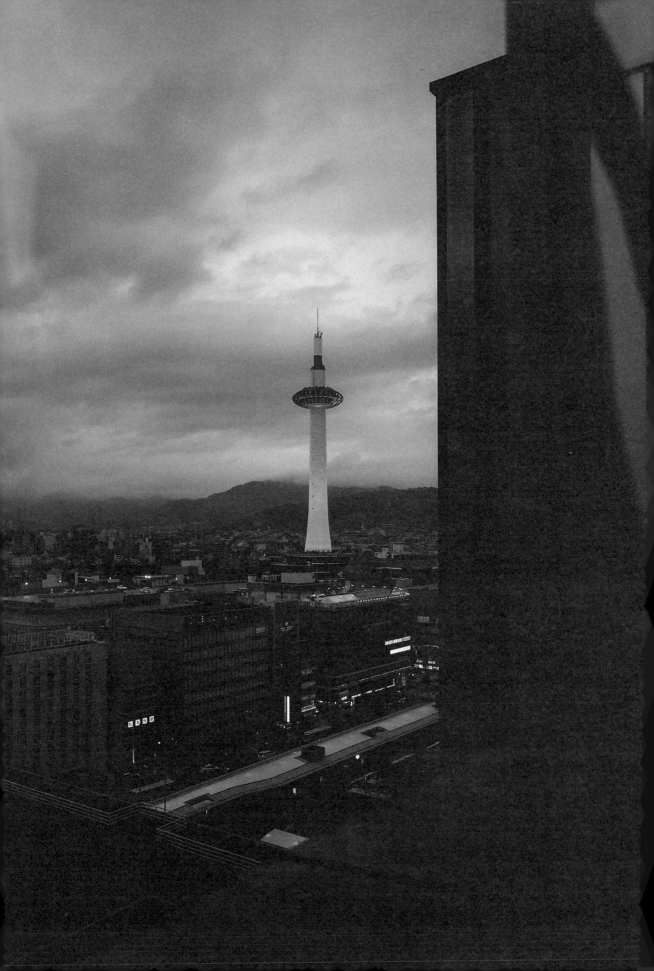

ACKNOWLEDGEMENTS

To my mom and dad, thank you for always encouraging me to explore and pursue my interests and dreams. I'm truly lucky to have had the chance to cultivate my passions with all of your encouragement and support.

To Raii, thank you for always believing in me no matter what. You've seen me during my best and my worst days, yet your support never wanes. Your appreciation for everything I do is the greatest gift.

To Sam, Lindy, Jack, and the rest of the Trope family, thank you for turning something I wouldn't have even dreamed of into a reality. It's a privilege to work with such an amazing team and to have my work shared by you.

To all the other photographers and artists that I've met and befriended along the way, thank you for all of the inspiration over the years. I'm grateful to be connected to such a creative group of people.

And finally to you, the reader, thank you for joining me on this journey. To be able to share it with you is more than I could ever ask for.

LCCN: 2021938621
ISBN: 978-1-9519630-4-0

Printed and bound in the Republic of Korea
First printing, 2022

Trope Publishing Co.

English translations reprinted with permission:

Page 9: Translated by Art Davis

Pages 15, 39, 65, 75, 109 and 135:
From wakapoetry.net, trans. T.E. McAuley

Pages 27, 57, 69 and 89:
From *Kyoto: A Literary Guide*, Camphor Press, 2020;
camphorpress.com/books/kyoto-literary-guide/

Page 97: From haikuguy.com/issa,
trans. David G. Lanoue

+ INFORMATION:
For additional information
on our books and prints,
visit trope.com